POSTCARD HISTORY SERIES

Philadelphia
South of Market
and East of Broad

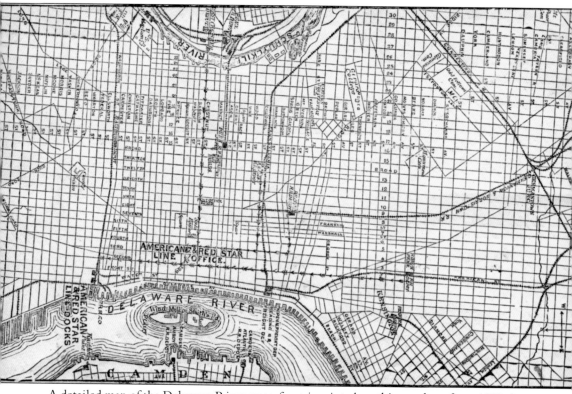

A detailed map of the Delaware River waterfront is printed on this envelope from 1899 that, at one time, contained passenger tickets for one of the American Line's seagoing pleasure vessels. The American Line, an international steamship company, advertised weekly transatlantic crossings that departed from its pier at the foot of Washington Avenue. (Author's collection.)

ON THE FRONT COVER: In 1908, traffic jams were already a major problem on Philadelphia streets. Horse-drawn wagons and electric trolleys clog the intersection of Market and Sixth Streets in front of Wanamaker & Brown's Oak Hall emporium, located on the corner. (Author's collection.)

ON THE BACK COVER: Three women sitting curbside ponder the woes of the world. In the background of this c. 1910 postcard, a vendor's pushcart displays its fresh fruits and vegetables for sale at the open-air Italian Market on South Ninth Street. (Author's collection.)

Philadelphia
South of Market and East of Broad

Gus Spector

ARCADIA
PUBLISHING

Published by Arcadia Publishing
Charleston, South Carolina

Printed in the United States of America

Library of Congress Control Number: 2013946728

For all general information contact Arcadia Publishing at:
Telephone 843-853-2070
Fax 843-853-0044
E-mail sales@arcadiapublishing.com
For customer service and orders:
Toll-Free 1-888-313-2665

Visit us on the Internet at www.arcadiapublishing.com

CONTENTS

ACKNOWLEDGMENTS

I am most happy to state that *Philadelphia: South of Market and East of Broad* is my fifth book in cooperation with Arcadia. I extend many thanks to my acquisitions editor, Abby Henry, who made sure that I got everything just right.

To my computer-savvy daughter, Rachel Hope Spector, I offer my loving expression of gratitude for her technical prowess and for the fact that she did not make fun of me when I thought that I had lost my entire manuscript somewhere in cyberspace.

This is my fourth Arcadia book that the delightful Eileen Wolfberg has proofread, offering me insightful and significant suggestions. Thanks so much for sharing your valuable time and your intimate knowledge of Philadelphia.

Clarence Wolf is a true scholar of Philadelphia history. I thank him for his in-depth review and critique of my manuscript and for his constant friendship.

Many thanks go to my friends at the Library Company of Philadelphia—Sarah Weatherwax, Erika Piola, and Nicole Joniec—who helped unearth a number of elusive details that would not otherwise have appeared in this book.

A special thanks goes to Al Cavalari, fellow postcard collector and American patriot, whose great knowledge of Independence Hall helped to enhance my understanding of the area.

Most important, words cannot express how fortunate I am to have Karen Spector as my wife, soul mate, and best friend.

Unless otherwise noted, all images are from my collection.

INTRODUCTION

There is no Fourteenth Street in Philadelphia. It is named Broad Street. There is no First Street in Philadelphia. It is called Front Street. The founding fathers planned Philadelphia on a grid system, which one would think easy to decipher. However, the occasional traveler lost in the city might do well to consult a guide map or, nowadays, a GPS or Internet map site, since its topographical quirks can be deceiving.

Philadelphia: South of Market and East of Broad is not meant to be a laundry list of significant Philadelphia landmarks on a street-by-street basis. Rather, the reader will find that the images contained within this book are grouped according to basic areas of the city. There are also several chapters that have been included just because they were fun to research. Chapter 1, titled "Old and Older," presents antique views of a number of Philadelphia landmarks, followed by more "contemporary" (i.e., early-20th-century) images of the same areas. For example, a postcard illustrating the location at Market and Seventh Streets where Thomas Jefferson wrote the Declaration of Independence in 1776 is matched with a comparable view from 1907.

It was impractical to illustrate every known postcard view of East Market Street in chapter 2, "Market Street Days." Instead, interesting and poignant views, spanning over 40 decades, have been presented. Market Street was replete with enough movie theaters to satisfy almost any taste. The facade of the early Unique Theatre, which ran continuous daily vaudeville performances, and the marquee of the Palace Theatre, were chosen as representative examples. Market Street was the epicenter of the city's many department stores; a history of their rise and fall has been capsulized.

Chapter 3, "Belly Up to the Bar," is a barhopping romp through some of Philadelphia's early-20th-century drinking establishments. As the saying goes, Philadelphia was "a great place to visit" and, evidently, a great place to partake of alcoholic beverages as well.

In chapters 4 and 5, this author has utilized his editorial prerogative, loosely grouping images according to their approximate locales within the city. The 1994 edition of the *Philadelphia Almanac and Citizens' Manual* and *Wikipedia* have been used as source material for the definitions of its various boundaries.

According to the 1994 almanac, Society Hill is located between Walnut and Pine Streets, from the Delaware River west toward Seventh Street. South Philadelphia is defined as the area south of South Street, between the Delaware and Schuylkill Rivers. The almanac also lists Washington Square area as being west of Society Hill, between Market and South Streets. Washington Square West is defined as the area encompassed between Seventh and Broad Streets and between Chestnut and South Streets. To add to this confusion, *Wikipedia* states that Washington Square West and Society Hill are both part of the Washington Square neighborhood.

Chapter 6, "Little Streets, Big Doings," focuses on some of the smaller streets and walkways made famous because of their historic contributions. Camac Street has been called "the Avenue of the Artists," a moniker that has been posted on a pole directly below the city's official Camac Street sign. Sansom Street, another of the important smaller streets, has long been dubbed "Jewelers' Row," the scenes of which presented in this chapter are of a varied nature.

Chapter 7, "North of South Street," brings to light a number of interesting snapshots of the quaint and picturesque area located between South and Chestnut Streets. Until the 1950s, South Street bustled with retail merchandisers, many of whom literally attempted to drag passersby off of the sidewalk and into their stores. Chapter 7 also includes views of historic Pennsylvania Hospital (the first hospital in the United States), the old and new buildings of the Historical Society of Pennsylvania, the Walnut Street Theatre, and several hotels reminiscent of a bygone era. The

Starr Garden Park, located on Sixth Street near Lombard Street, is featured at a time when it was still a fledgling addition to the community. Located on Sixth Street, directly across from Starr Garden Park, was the tiny storefront business of Levis' Hot Dogs, of which, disappointingly, no postcard exists.

Chapter 8, "Heading Toward the South of the City," portrays the neighborhood streets, the places of worship, and the nostalgia of South Philadelphia, including its Italian Market. This large section of the city, once predominately populated by those of Eastern and Western European ancestry, is now home to many of Asian and Hispanic origins.

The title of chapter 9, "The Broad Street Run," is a play on words, in this book pertaining to the length of Philadelphia's South Broad Street. Its actual meaning, however, is a reference to an annual event that has been taking place since the 1980s. The largest 10-mile footrace in the United States, the Broad Street Run is a gala event scheduled each year on the first Sunday in May. In 2012, a total of 40,689 participants ran along Broad Street from T.S. (Taras Shevchenko) Park in the Logan neighborhood of North Philadelphia, past city hall, and down to the finish line at the Navy Yard in South Philadelphia.

Chapter 9 mentions the terms "the Neck" and "the Ma'sh" (marsh), which were, in the late 19th century, the southernmost limits of the city. The Neck originally included all of the land south of Moore Street, and the Ma'sh consisted of the swampy marshes closer to Broad Street. In 1920, writer Christopher Morley had traveled to the Neck and thus predicted, "A landscape architect would go mad with joy if given the delightful task of planning The Neck as a park." Philadelphia indeed selected the regions around the Neck and the nearby Ma'sh for the 1926 Sesquicentennial International Exposition. As late as the 1950s, the Neck was populated by squatters known as "Neckers," who dwelled illegally on this unimproved land, setting up housekeeping inside of tar paper lean-tos.

Paraphrasing Joseph Jackson's *Philadelphia Year Book for 1919*, the following is a schematic of the streets located south of Market Street and perpendicular to Broad Street. Each number denotes the block's distance from Market Street:

Market	1600 Tasker	3300 Geary
100 Chestnut	1700 Morris	3400 Hartranft
200 Walnut, Locust	1800 Moore	3500 Hoyt
300 Spruce	1900 Mifflin	3600 Pattison
400 Pine	2000 McKean	3700 Beaver
500 Lombard	2100 Snyder	3800 Hastings
600 South	2200 Jackson	3900 Stone
700 Bainbridge, Fitzwater	2300 Wolf	4000 Pennypacker
800 Catherine, Queen	2400 Ritner	4100 Stuart
900 Christian, Montrose	2500 Porter	4200 Tener
1000 Carpenter	2600 Shunk	4300 Brumbaugh
1100 Washington Avenue, Ellsworth	2700 Oregon	4400 Forty-fourth Avenue
	2800 Johnston	4500 Forty-fifth Avenue
1200 Federal	2900 Bigler	Government Avenue
1300 Wharton	3000 Pollock	League Island
1400 Reed	3100 Packer	
1500 Dickinson	3200 Curtin	

A few of the higher numbered streets (e.g., those located closer to League Island and the Navy Yard) no longer exist, having been replaced by housing developments, the sports complex, and the off-ramp of Pennsylvania's Interstate 95.

Hopefully, the above will enhance the reader's appreciation of the various locations discussed within this book.

One

OLD AND OLDER

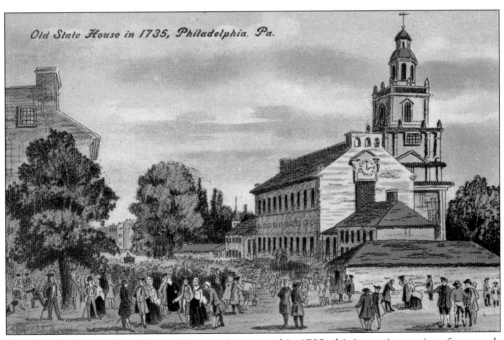

Showing the Pennsylvania State House as it appeared in 1735, this is one in a series of postcards issued to commemorate Founder's Week in Philadelphia in October 1908. Built between 1732 and 1748, the structure is known today as Independence Hall. The Declaration of Independence, signed in the state house in 1776, announces that the 13 American colonies no longer regard themselves as part of the British Empire.

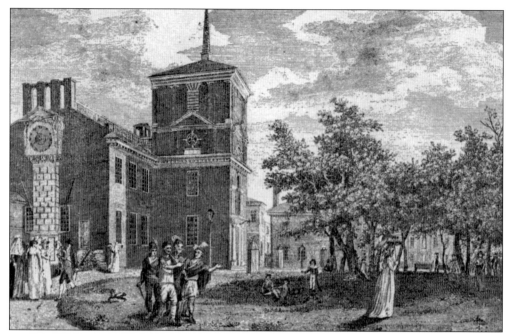

A second postcard from the 1908 Founders' Week series reproduces William Russell Birch's finely executed engraving of the back of the state house. His original 27 views were published under the title *The City of Philadelphia: As It Appeared in the Year 1800*. Between 1750 and 1753, a clock and a tower, topped by a wooden steeple, were added to the state house.

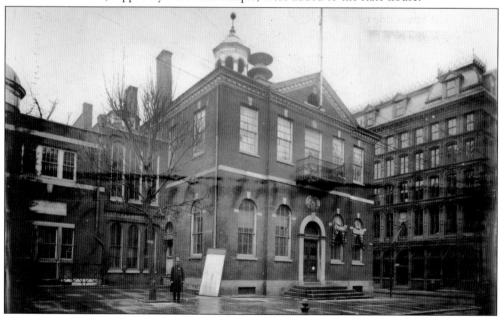

In 1812, Robert Mills, a prominent architect, was presented with the task of redesigning the exterior facade of the state house complex. For his alterations to respect 19th-century taste, needs, and fireproofing, the original piazzas and wing buildings were demolished and replaced with a row house design. In this undated photograph, a policeman stands just to the right of one of the wings of the stylistic two-story Mills building.

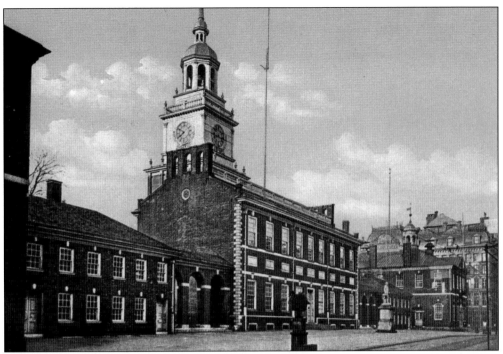

Robert Mills had actually designed matching wings for his new additions, one building on either side of Independence Hall. This postcard from 1919 reveals that Mills's buildings seen in the previous image have been removed and replaced by sets of arcades, best appreciated from the Chestnut Street side of Independence Hall.

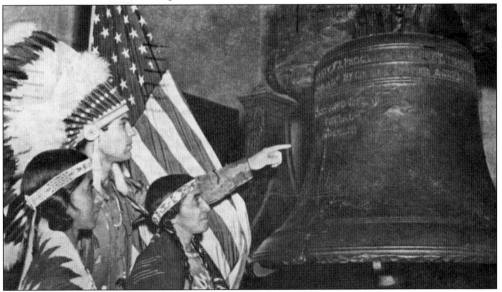

In 1751, a bell was created to commemorate the 50-year anniversary of William Penn's Pennsylvania charter. In 1893, America's iconic symbol of freedom, known as the Liberty Bell, was transferred from its belfry and displayed in the first-floor tower vestibule of Independence Hall, suspended from its original yoke. This 1949 postcard commemorates a visit to the Liberty Bell by White Eagle, a Camp Lenape Native American.

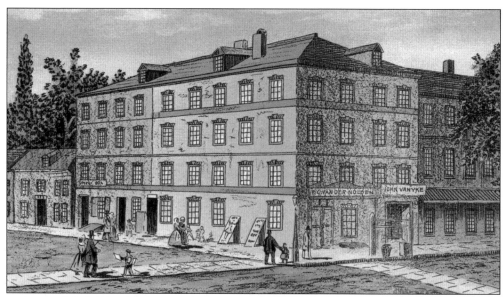

In 1775, Philadelphia bricklayer Jacob Graff Jr. built a house on the corner of Seventh and Market Streets, an area bordering on the outskirts of the city at that time. Thomas Jefferson, a 33-year-old delegate from Virginia to the Continental Congress, rented its two second-floor rooms, where he drafted the Declaration of Independence.

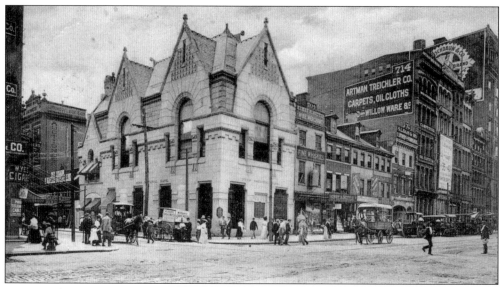

By 1907, the character of the city had been radically altered. The Penn National Bank, built between 1882 and 1884 and demolished prior to 1932, now occupied the corner of Seventh and Market Streets. Thereafter, a fast-food restaurant remained at the site until the 1970s. In 1975, in preparation for the bicentennial, the National Park Service reconstructed a replica of the Graff House at that location.

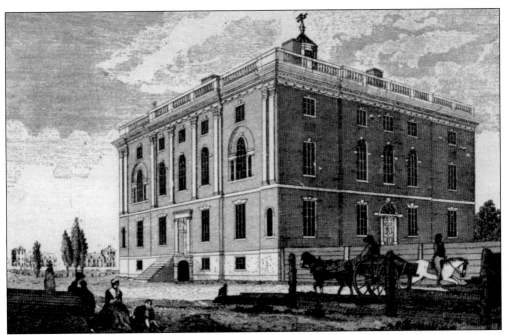

In 1792, construction for George Washington's presidential mansion had begun on the west side of Ninth Street, just south of Market Street. However, due to an extended period of time for its completion, President Washington never occupied the mansion, instead living in a "smaller" house situated below Sixth and Market Streets. This postcard reproduces Birch's *The House intended for the President of the United States, in Ninth Street.*

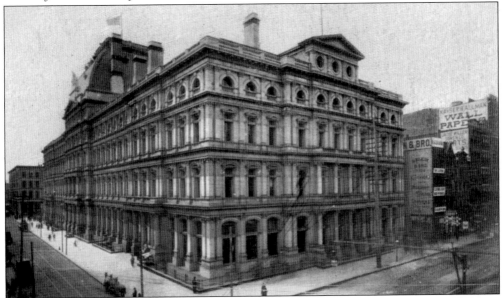

Although ground breaking for the post office seen in this 1908 postcard occurred in 1873, the building was not ready for occupation until 1884. The huge granite edifice was erected on the site at Ninth Street, between Chestnut and Market Streets, at a cost of $7,265,487.77 (equivalent to $176,242,672.31 today). A more modern US courthouse and post office building replaced it in 1935.

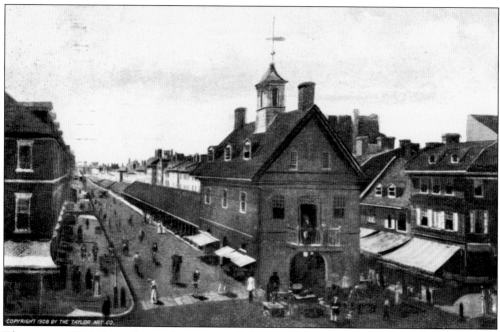

There was a High Street in nearly every English town, and Philadelphia was no exception. In 1707, the Great Town House, a series of mercantile sheds, stood in the middle of High Street, between Front and Fourth Streets, eventually extending to Sixth Street after 1810. The last shed was demolished about 1860. The postcard is from 1908.

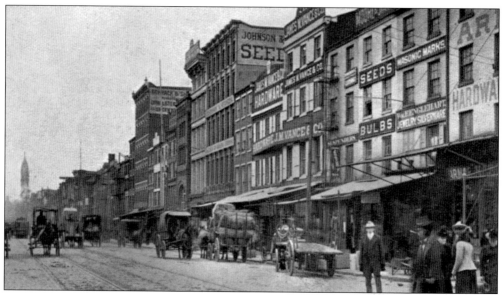

This is a 1910 view of the north side of Market Street, between Second and Third Streets. The market sheds in the above view from 1707 have long since been removed, with trolley tracks in their stead. The name High Street became obsolete around 1800.

14

The Walnut Street Jail (Gaol), situated between Fifth and Sixth Streets, was constructed in 1773 and demolished around 1835. Balloonist Jean Pierre Blanchard, a French citizen, accomplished America's first air voyage in 1793. Blanchard was granted permission to lift off from the prison yard because it was spacious and devoid of trees. Artist Charles Reed Gardner (1901–1974) created the woodcut in this 1938 postcard.

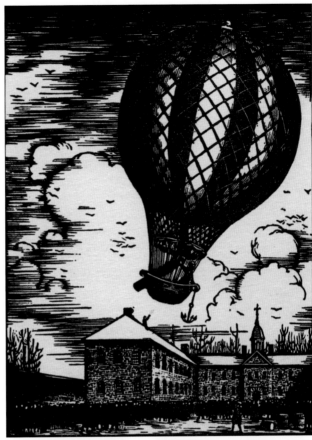

Tulips were in full bloom on Independence Square's lawn, located at the rear of Independence Hall, when this postcard view was taken around 1910. The row of buildings seen in the far right background is situated in the 500 block of Walnut Street, the land originally occupied by the Walnut Street Jail. The houses to the left line South Fifth Street.

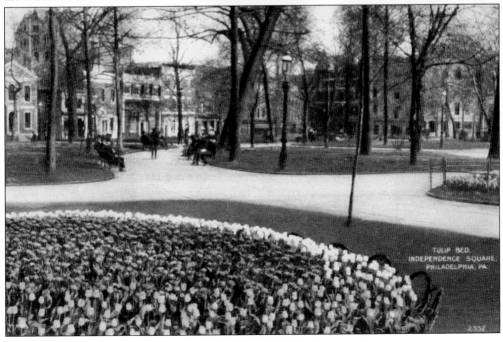

TULIP BED,
INDEPENDENCE SQUARE,
PHILADELPHIA, PA

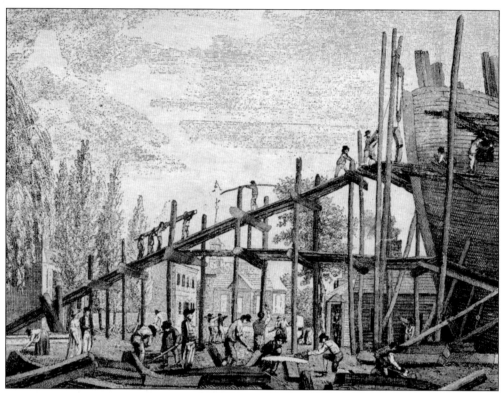

Birch's view is captioned, "Preparation for WAR to defend Commerce." In 1798, the frigate *Philadelphia* was built at Humphrey's shipyard, located near Delaware Avenue and Christian Street in the Southwark section of the city, as part of the response to the French seizure of ships belonging to neutral American citizens. Old Swedes Church can be seen in the background.

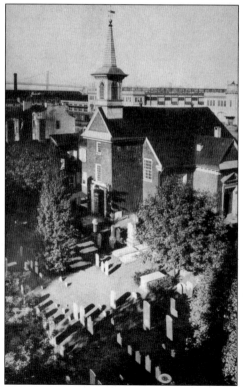

Gloria Dei (Old Swedes) Church is the oldest church in Pennsylvania and the second-oldest church in the United States. Located at Columbus Boulevard (formerly Delaware Avenue), it was erected between 1697 and 1700. Although originally founded by Swedish Lutherans, it has been Episcopalian since 1845. This view was taken after 1926, as the Delaware River (Benjamin Franklin) Bridge can be seen in the far background.

Two

MARKET STREET DAYS

In 1938, radio station WFIL helped celebrate the 250th anniversary of the founding of Market Street by airing a formal radio pageant. Why the year 1688 was chosen as Market Street's founding remains unclear.

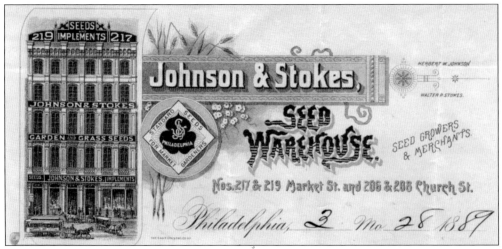

The Johnson & Stokes Seed Warehouse, as seen on its illustrated billhead, was located at 217–219 Market Street. The letterhead's date, given as "third month, twenty-eighth day [of] 1889," is a Quaker notation. The store can also be viewed in the postcard on page 14, situated in the middle of the 200 block of Market Street. The building remains today, having been upgraded in a very stylistic manner.

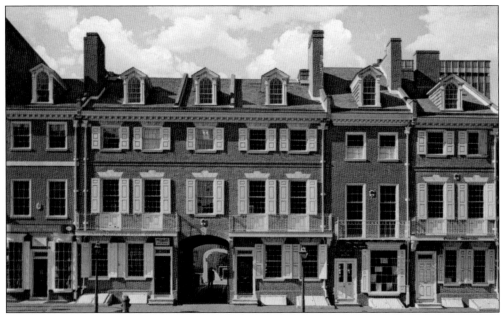

The restoration of Benjamin Franklin's row of Market Street houses, five brick homes located at 314–322 Market Street, was completed in time for the nation's bicentennial celebration in 1976. The row now includes a US post office, a print shop, and an archaeological exhibit. (Courtesy of Robert Gordon, Wyco Colour Productions.)

James M. Vance was a jobber (i.e., wholesaler) and importer of hardware. In 1910, his new quarters were located in a six-story building at 324–326 Market Street. The plot is now a narrow gated court, situated next to Franklin's row of homes.

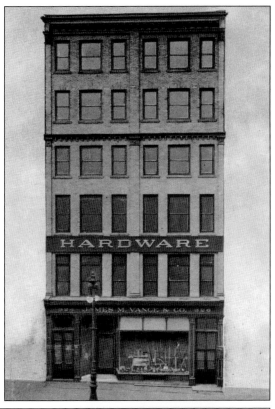

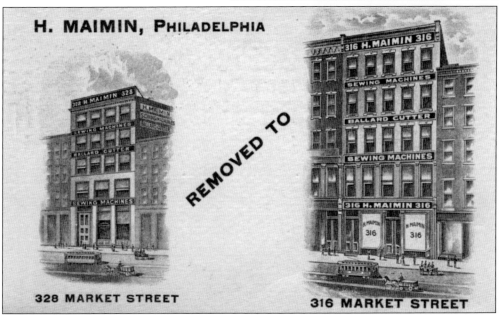

Hyman Maimin is listed in Gopsill's *Philadelphia Business Directory for 1907* as being a manufacturers' agent for sewing and ballard (cloth-cutting) machines. This government postal card from 1907 was mailed to his customers, announcing that he had moved from his former location at 328 Market Street to bigger and better quarters down the street at 316 Market Street.

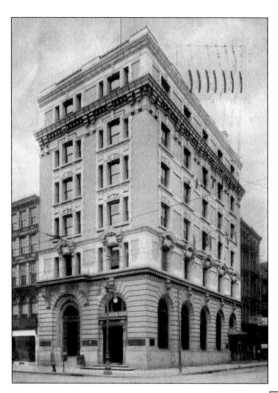

In 1910, the Central Trust & Savings Company was located on the northwest corner of Market and Fourth Streets. The bank boasted a capital surplus of $1.125 million (today, over $27 million). Subsequent to the bank's closure, the ground floor was refurbished as a cafeteria. A multistory office complex has replaced the building.

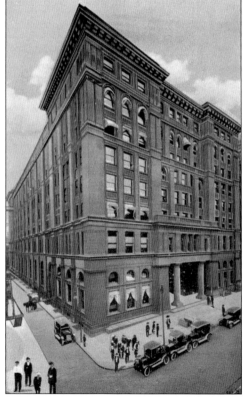

The Philadelphia Bourse, located on South Fifth Street, was constructed between 1893 and 1895. Designed by architects Hewitt and Hewitt in the Beaux-Arts style, it was one of the first steel-frame buildings. The bourse, seen here around 1920, ceased functioning as a commodities exchange in the 1960s. Its first floor has been reconfigured as a food court.

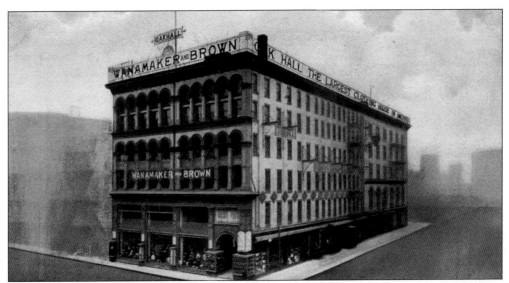

John Wanamaker and Nathan Brown's Oak Hall was located on the southeast corner of Sixth and Market Streets. In 1861, the two risk takers pooled their combined savings of $4,000 and opened Philadelphia's first department store. The building no longer exists, but the National Park Service has memorialized this historic corner as the site of George Washington and John Adams's executive mansion between 1790 and 1800.

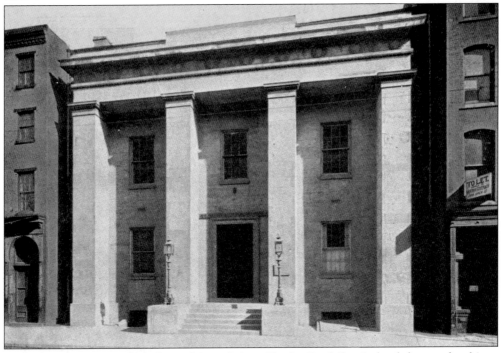

The Franklin Institute of Mechanical Arts, designed in the Greek Revival style by noted architect John Haviland, occupied the building located at 15 South Seventh Street between 1825 and 1933. In 1938, it was purchased by A. Atwater Kent, a radio pioneer magnate, and donated to Philadelphia as a city museum. It is currently known as the Philadelphia History Museum at the Atwater Kent. This is a c. 1910 postcard.

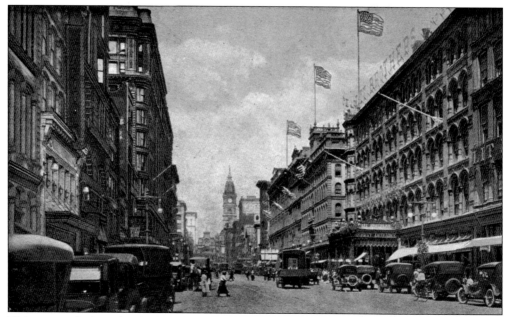

This postcard view, dated 1924, focuses on Market Street, looking west from Seventh Street. Occupying the entire block between Seventh and Eighth Streets, Lit Brothers (right) consists of 33 buildings constructed between 1859 and 1918, all with a common interior. Lit Brothers closed in 1977. The 562-seat Capitol Theatre, whose marquee is seen directly across the street, was open between 1919 and 1954.

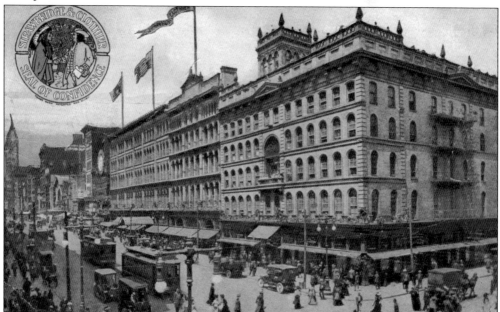

Quaker entrepreneurs Justus Strawbridge and Isaac Clothier opened their dry goods store in 1868 on the northwest corner of Eighth and Market Streets, in a building that had been Secretary of State Thomas Jefferson's office between 1790 and 1793. The historic building was demolished as their business expanded. Their colossal store and the Strawbridge & Clothier's "Seal of Approval" are seen on this postcard from 1913.

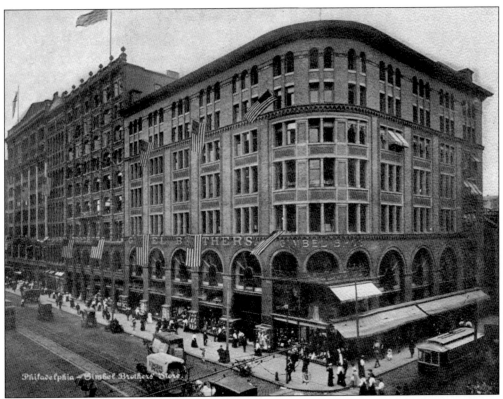

Adam Gimbel opened his Philadelphia department store in 1894 on the southeast corner of Ninth and Market Streets, the site of the former Granville B. Haines & Co. building. Between 1896 and 1900, additions and alterations resulted in the iconic structure captured on this c. 1905 postcard. Demolished in 1978, the Gimbel's property is now a large parking lot.

Leary's Bookstore was known as the oldest bookstore in America. It closed in 1969, having been located at 9 South Ninth Street for almost a century. Leary's three-story building was literally crammed to the rafters with new and used books. An open-air stall in an alleyway separating it from Gimbel's Department Store allowed browsers to peruse many thousands of inexpensive books. This is a c. 1900 illustration.

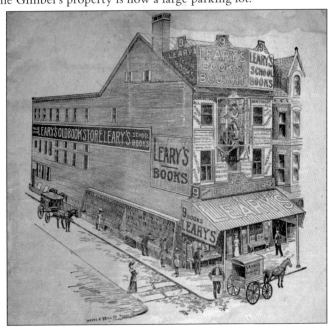

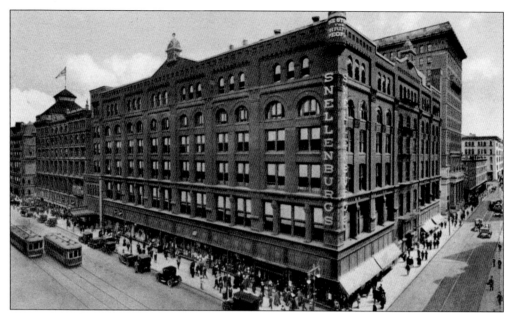

In 1889, Snellenburg & Company opened its department store on the south side of Market Street, between Eleventh and Twelfth Streets. As a major clothing manufacturer, the company was able to sell directly from its factory to its customers, hence acquiring the slogan "The Thrifty Store for Thrifty People." Snellenburg's closed in 1962, and a Modernist three-story building marks the site today. This card was postmarked in 1916.

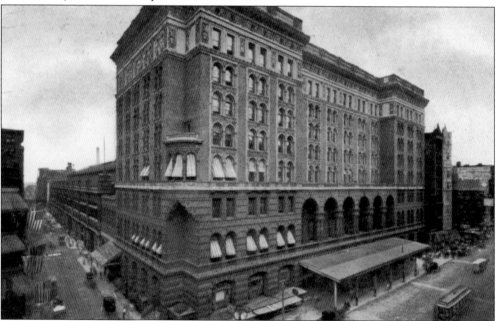

The Reading Terminal train station, designed by Wilson Brothers & Company, was constructed between 1891 and 1893 at the northeast corner of Twelfth and Market Streets. Due to its topography, the train shed and tracks were raised one story above street level. The Reading Railroad declared bankruptcy in 1971, but commuter train service continued until 1984. The building's current facade is quite different from that seen in 1911.

Kitty-corner to the Reading Terminal is the 36-story Pennsylvania Savings Fund Society (PSFS) building, situated at 12 South Twelfth Street. Designed by architects Howe and Lescaze, it was built between 1929 and 1932 and designated as the first modern skyscraper constructed in the United States. The iconic "PSFS" sign, located atop the building's tower, is not visible in this 1937 postcard view taken from North Twelfth Street.

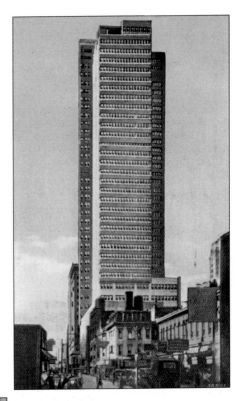

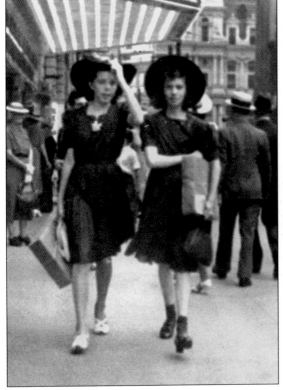

On a breezy day in August 1939, an itinerant commercial photographer transformed Jeanne McKeaney and Natalie Nevins, passing beneath the marquee of the Palace Theatre at 1214 Market Street, into postcard pinups. The 1,106-seat Palace Theatre, built in 1908, was demolished in 1971. City hall can be seen in the far background.

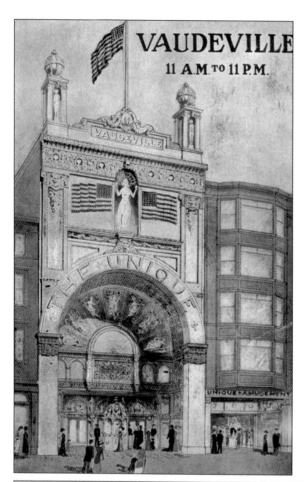

The c. 1910 Unique Theatre was located at 1217–1223 Market Street, across the street from the Palace Theatre site. As advertised on the card, the Unique presented continuous daily vaudeville acts. An amusement concession situated next door to the theater afforded patrons further forms of fun.

Market Street, in this view looking eastward from a city hall window, is seen around 1915. Wanamaker's Department Store (right) occupies the entire south side of the 1300 block of Market Street. Built between 1902 and 1910, Wanamaker's housed the Grand Court Organ, the world's largest operational pipe organ, originally played at the 1904 St. Louis Exposition.

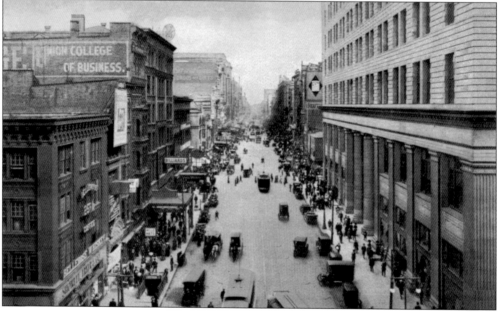

Three

BELLY UP TO THE BAR

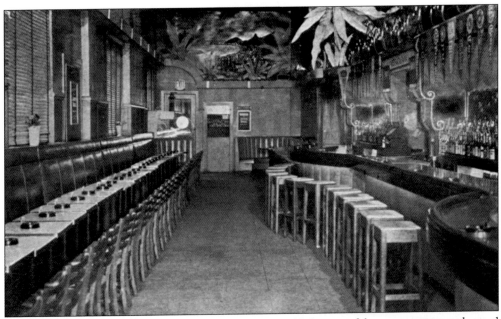

The Copacabana, not to be confused with any other establishment of the same name, was located on the corner of Juniper and Locust Streets. The front bar and lounge, seen in this 1947 view, are decorated in a tropical motif, a banana tree hanging mid-ceiling. The Copacabana described itself as "Philadelphia's most beautiful musical bar" and "The home of Atomic Entertainment."

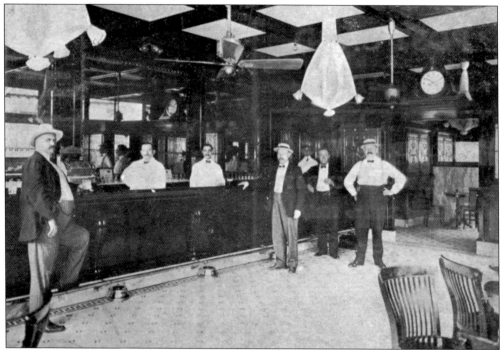

Charles Hunt's postcard, dated August 11, 1908, advertises the grand opening of his bar, located on the southeast corner of Third and Market Streets. The card advises his patrons that S. Fred Herberg of Philadelphia manufactured the bar fixtures and that Stoeckle's Wilmington Beer is served on tap. The gentleman at the far left certainly has his "belly up to the bar."

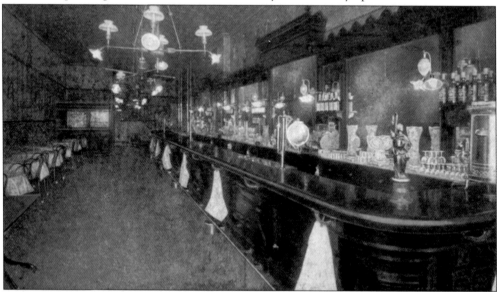

Harvey Ringler's Saloon, located at 632 Market Street, was three blocks west of Charles Hunt's establishment. A mammoth, highly polished mahogany bar is seen on the right. A separate ladies' buffet was served upstairs on the second floor. This postcard was probably printed prior to the enactment of the 1920 Volstead Act that prohibited the sale of intoxicating beverages. A multistory parking lot now dominates this Market Street site.

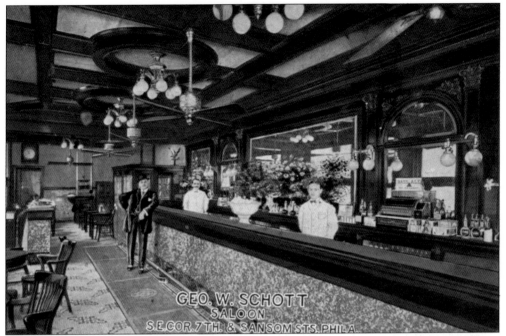

In 1907, the George W. Schott Saloon was located on the southeast corner of Seventh and Sansom Streets, the current site of the Curtis Publishing Company building. In this view, two bartenders are patiently poised, waiting for customers, as a dapper man, appearing most relaxed, leans against the bar. The Seventh Street portion of Sansom Street is now known as "Jewelers' Row."

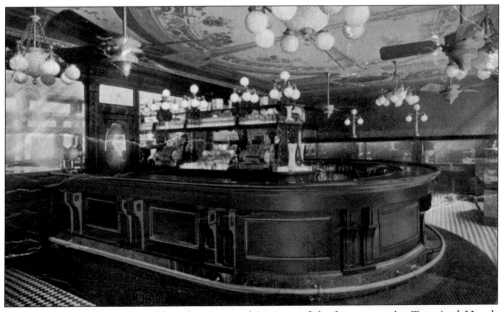

An ornate horseshoe-shaped bar dominates this view of the lounge at the Terminal Hotel, located at Twelfth and Filbert Streets, also under the proprietorship of George W. Schott. This postcard is of a slightly later vintage than that of Schott's Sansom Street establishment seen in the previous image.

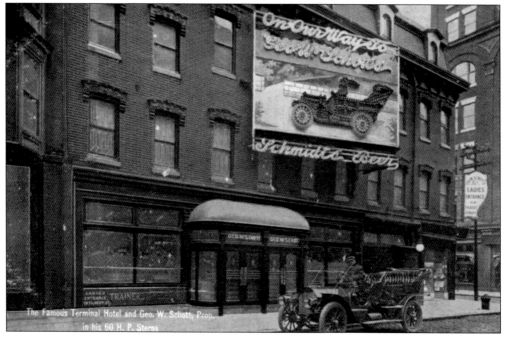

Proprietor George W. Schott is pictured in front of his Terminal Hotel, seated in his 60-horsepower 1907 Stearns touring car. In 1907, a Stearns sold for $4,500 (equivalent to $11,000 today). The garish electric sign over the front door blatantly bespeaks his wealth.

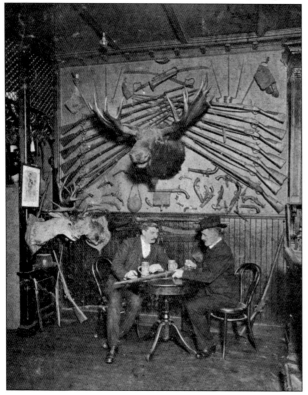

Two customers are seated in front of the gun exhibit at Ostendorff's Gentlemen's Café, situated at 1231 Market Street. German cafés and biergartens were popular throughout the city until the onset of World War I, when anti-German sentiment became rife. A Marriott hotel now stands on the former site of Ostendorff's Café.

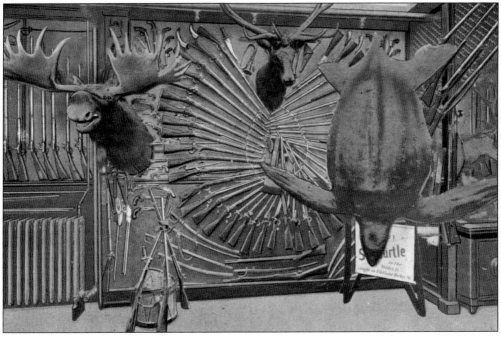

This is a close-up of Ostendorff Café's exhibit of weapons, all of which were manufactured between 1860 and 1905.

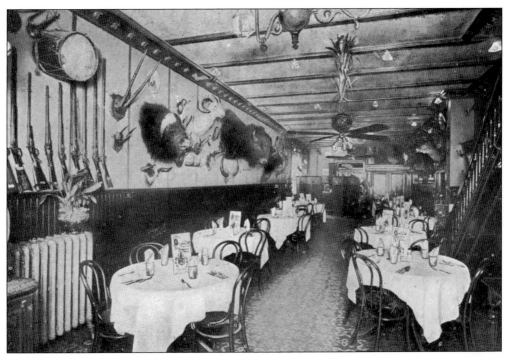

Ostendorff's guaranteed that its larder was always well stocked with "everything in season." This 1908 view shows the length and breadth of the establishment. Note the thematic wildlife taxidermy adorning its walls.

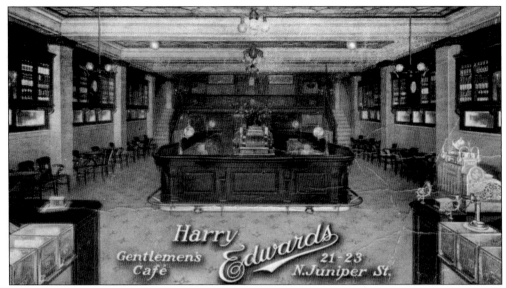

The Harry Edwards Gentlemen's Café was located just above Market Street, at 21–23 North Juniper Street. It is seen here well decked out in the fashion of the day, with a large bar area and generous seating. The postcard is from 1906.

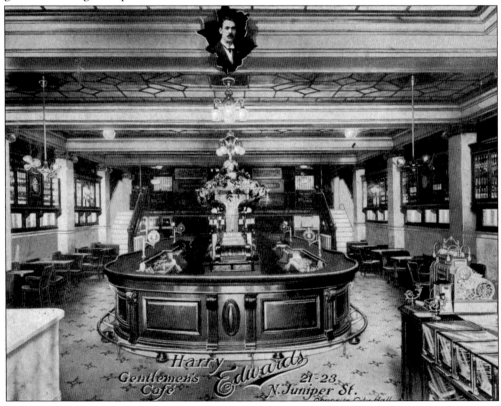

Harry Edwards advertised that his café was "in the heart of Philadelphia, near the Reading Railroad Station (located at Twelfth and Market Streets), all theatres and—'everywhere.'" Handsome Harry's picture is seen in the inset at the top of the card.

Four

Dock Street, New Market, and the Delaware River

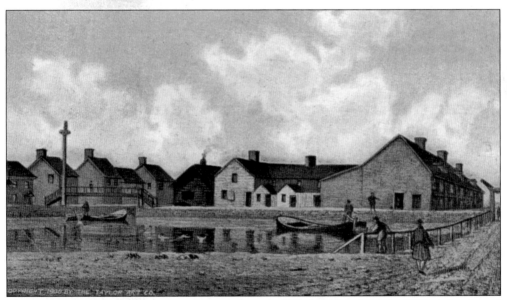

Tradition states that William Penn first set foot on Philadelphia's shore in 1682 at the sign of the original Blue Anchor Inn, located at Front and Dock Streets. At that time, there were three branches of the Dock Creek, one of which flowed into the vicinity of the Blue Anchor, seen illustrated in this postcard from 1907.

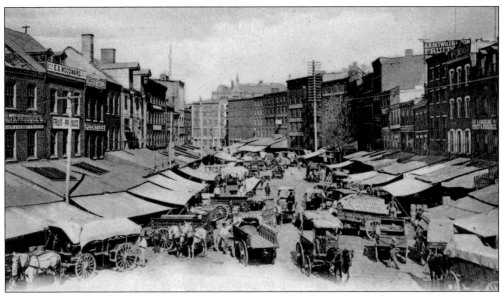

Only three blocks long, Dock Street was Philadelphia's center for wholesale and retail produce supply. Fresh fruits and vegetables were delivered from ships docking along the Delaware River. Produce was off-loaded from the many Dock Street warehouses to the waiting wagons, snarling traffic throughout this circuitous street, as seen in 1905. Between 1957 and 1959, all the buildings were demolished, the area being revitalized as the Society Hill Towers.

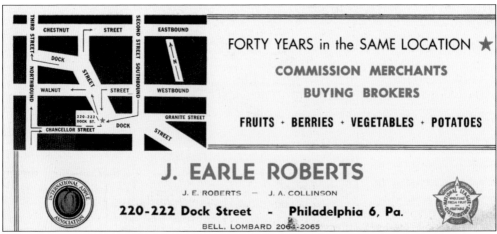

J. Earle Roberts was one of many commission merchants whose businesses were located along the Dock Street route. Such merchants bought and sold goods for others on a commission basis. The map shows Dock Street's serpentine course and pinpoints the site of Roberts's establishment.

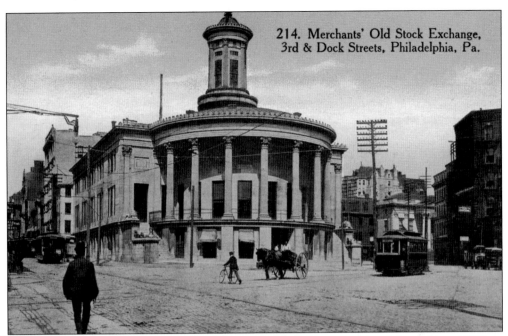

214. Merchants' Old Stock Exchange, 3rd & Dock Streets, Philadelphia, Pa.

The Merchants' Exchange Building was designed in the Greek Revival style by architect William Strickland. Built between 1832 and 1834, the Exchange, bounded by Dock, Third, and Walnut Streets, served as the Philadelphia stock exchange until 1875. In this c. 1910 view, Walnut Street is to the left and Dock Street is to the right. The building is currently the headquarters of the Independence National Historical Park.

In the 1840s, private mail carriers competed with the federal government to deliver the mail. D.O. Blood & Co. issued its own "postage stamps," depicting one of its letter carriers leaping over the Merchants' Exchange Building, which also served as the government post office. The symbolism was obvious: Blood could deliver the mail much more efficiently than the US government.

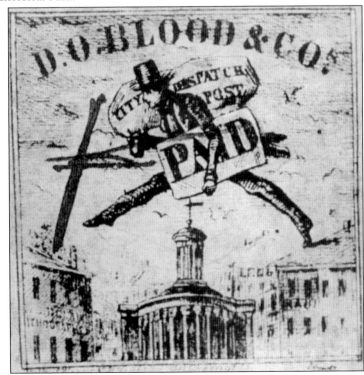

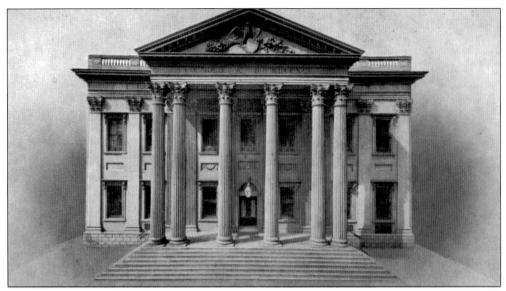

Based on Alexander Hamilton's recommendations, Congress chartered the First Bank of the United States in 1791, and the building was completed in 1795. In 1812, when its 20-year charter expired, the building was purchased by Stephen Girard, who remained as the sole proprietor of Girard's Bank until his death in 1831. Located at 120 South Third Street, it is listed as a National Historic Landmark.

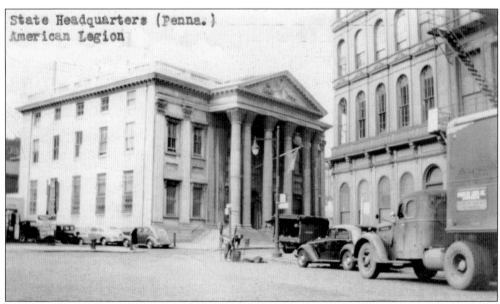

In 1942, the Pennsylvania State Headquarters of the American Legion occupied a portion of the First Bank of the United States.

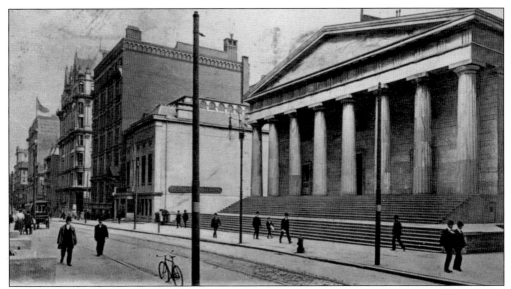

Completed in 1824, the Second Bank of the United States was designed in the Greek Revival style by architect William Strickland, creating an appearance similar to a classic Greek temple. The bank closed in 1841 and, in 1845, became the US Custom House. It is currently part of Independence National Historical Park. Seen in this postcard from 1907, it is located at 420 Chestnut Street.

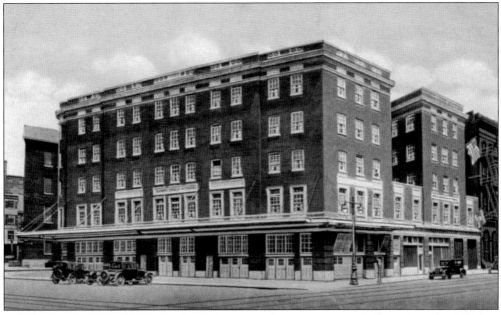

The Seamen's Church Institute was located at 211 Walnut Street, a stone's throw from the Delaware Avenue waterfront. Merchant seamen were offered respite within its five-story building in the form of 230 hotel rooms, an auditorium, a restaurant, and a chapel. The institute was demolished in 1957 as part of the Independence National Park rehabilitation program.

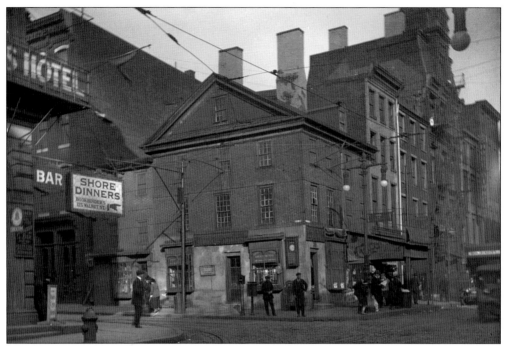

Built in 1751 as a home for American portrait artist John Drinker, Krider's Gun Store, situated on the northeast corner of Second and Walnut Streets, was photographed around 1920 by Alfred Hand. Deemed unsafe for habitation, the building was demolished in 1955. (Courtesy of the Library Company of Philadelphia.)

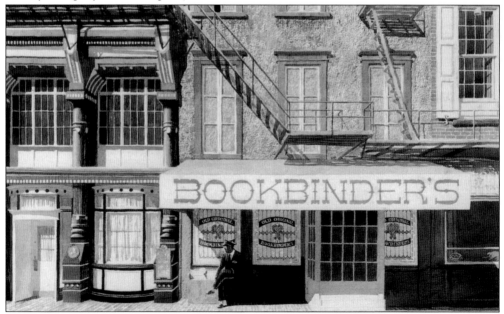

The Old Original Bookbinder's restaurant was a landmark seafood establishment located at 125 Walnut Street, next door to the Drinker House/Krider Gun Store. Upon its demolition in 1955, architect Grant Miles Simon, then chairman of the Philadelphia Historical Commission, designed an accurate copy of the colonial Drinker home as a banquet facility for Bookbinder's.

The 1804 Head House on South Second Street, between Pine and Lombard Streets, was part of New Market, a block-long aggregate of merchant stalls. Located on the north end of the market, the Head House was a firehouse designed in the Georgian style. At one time, its cupola contained a fire bell. This is a c. 1907 postcard.

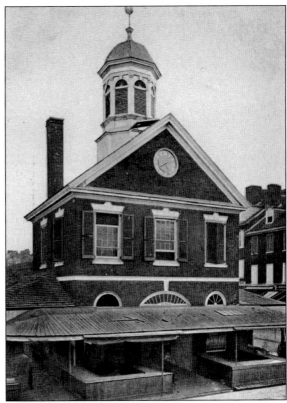

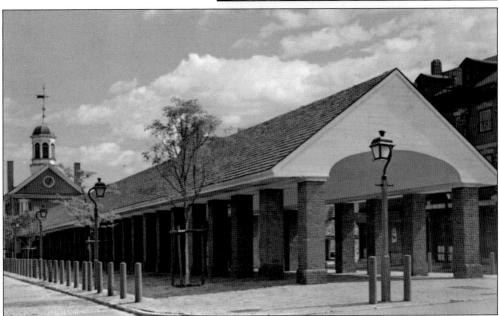

This is a more modern view of New Market, seen from the Lombard Street side. An enclosed rat-infested market structure had been demolished in 1950, replaced by this open-air arcade in the 1960s. The Head House was also restored, retaining its original style of ornamentation. A weekly farmers' market inhabits this space from May until Christmas.

The author took this photograph in 1977, prior to the demolition of many colonial homes in the Head House Square area. These sagging wrecks were located on Second Street, near Pine Street.

In the 1970s, a commercial photojournalist snapped this view of Head House Square in Society Hill. Buildings dating back to the 18th century had been restored as museums, taverns, restaurants, and private homes.

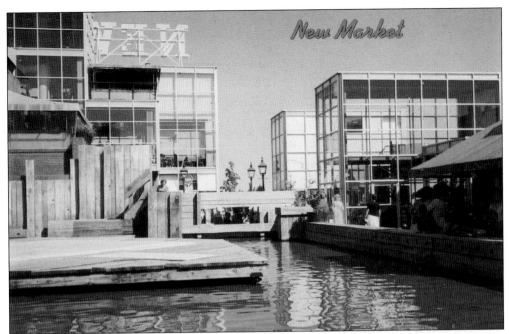

The New Market at Head House Square (not to be confused with the Head House itself) was dubbed "the Glass Palace." Built in 1973, it was located between Second and Front Streets, below Pine Street, and consisted of a multilevel complex of original colonial buildings and contemporary glass architecture. It has since been demolished, and there are plans to redevelop the site.

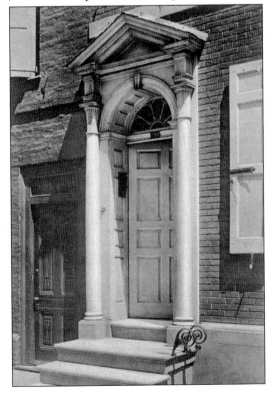

This doorway, part of an early architectural postcard series from about 1915, illustrates the entrance to the colonial home located at 239 Pine Street. This residence remains standing today.

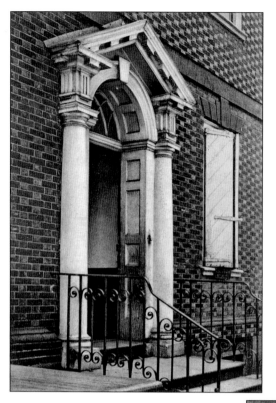

Another postcard from this architectural series focuses on the doorway of 224 Pine Street, a colonial dwelling built in 1750. This house was located across the street from the one seen on the previous page.

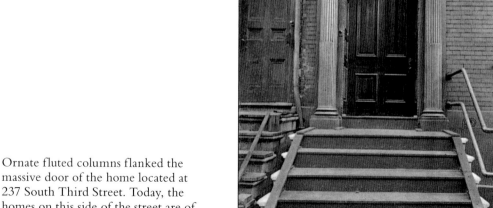

Ornate fluted columns flanked the massive door of the home located at 237 South Third Street. Today, the homes on this side of the street are of modern construction.

A simple wooden spire rises from atop the 5.5-story tower of St. Peter's Church. The church, located at Third and Pine Streets, was erected between 1758 and 1761 as a branch of Christ Church. During the winter of 1781–1782, Gen. George Washington and his wife, Martha, attended services here. The postcard view is from 1908.

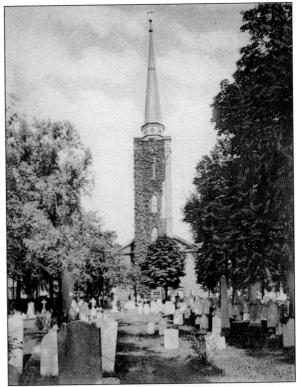

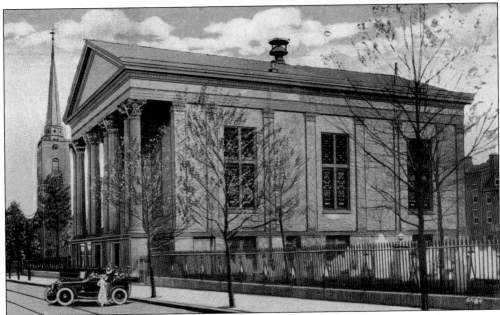

Old Pine Street Presbyterian Church, located at 412 Pine Street, was founded at its present site in 1768 and built in the Greek Revival design in 1837. A portion of the huge raised portico, with its fluted Corinthian columns, can be seen in this view on the left (Pine Street side) of the building. The spire of St. Peter's Church is seen in the background. The card was postmarked in 1919.

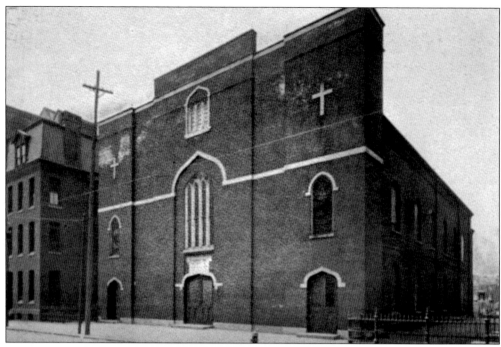

St. Mary's Church, built in 1763 and enlarged in 1810, is located at Fourth Street, near Spruce Street. It is the second-oldest Roman Catholic church in Philadelphia. In 1808, coincident with the appointment of an American bishop, St. Mary's became a cathedral. The postcard is from 1908.

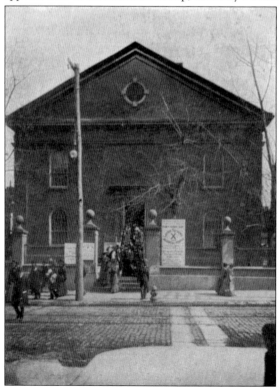

St. Paul's Protestant Episcopal Church, seen in this postcard from 1909, is located on Third Street, below Walnut Street. The reverse of the card advertises daily noonday Lenten services for businesspeople, the doors closing "precisely at 12:55."

The Powel House, located at 244 South Third Street, almost across the street from St. Paul's Church, built around 1765, was the residence of Philadelphia's last pre–Revolutionary War mayor, Samuel Powel. It was considered the last colonial dwelling frequented by George Washington while he was in Philadelphia. Powel died in 1793, a victim of the yellow fever epidemic that year. This is a c. 1935 postcard.

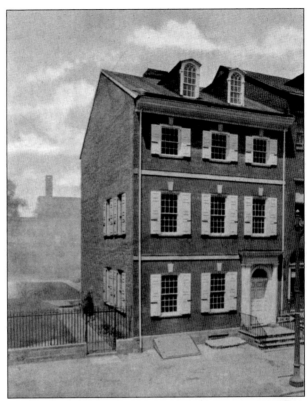

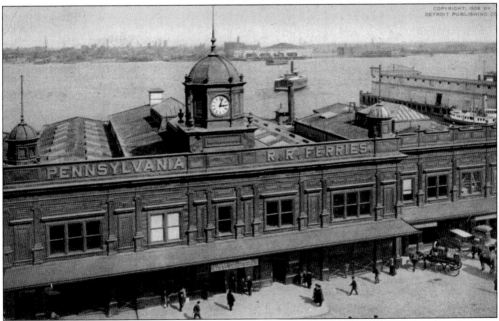

Prior to construction of the Delaware River (Benjamin Franklin) Bridge in 1926, passengers relied on the Pennsylvania Railroad ferries to transport them to Camden, New Jersey. This postcard from 1908 shows the elongated ferry berths at the rear of the terminal buildings, which were located at the foot of Market Street. Camden is seen on the far side of the river.

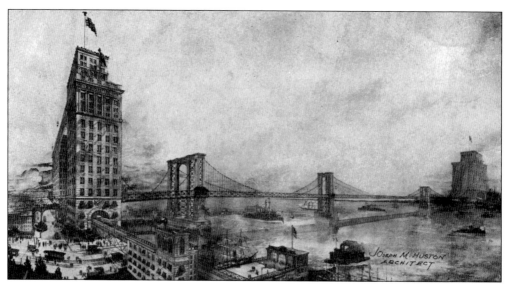

This is an architect's rendition of the proposed William Penn Memorial Bridge, set to span the Delaware River. The postcard, date unknown, is an advertisement for donations to the publicity fund of a bridge that never came to fruition. The Delaware River Bridge, however, was opened to traffic in 1926, obviating the need for the Market Street Ferry.

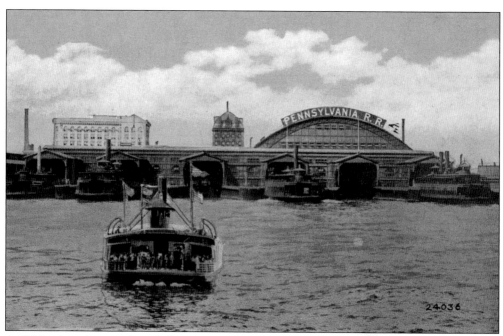

A 1920s view shows a ferry laden with passengers crossing the Delaware River between the Philadelphia and Camden piers. The berths of the Market Street ferry pavilion are seen in the background.

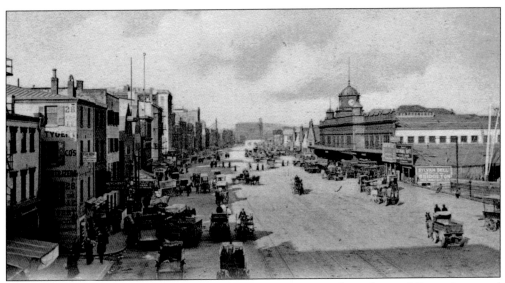

In this 1904 image, Delaware Avenue at Chestnut Street is a very busy thoroughfare, crisscrossed by multiple train tracks. The Market Street ferry terminal can be seen at the far upper right.

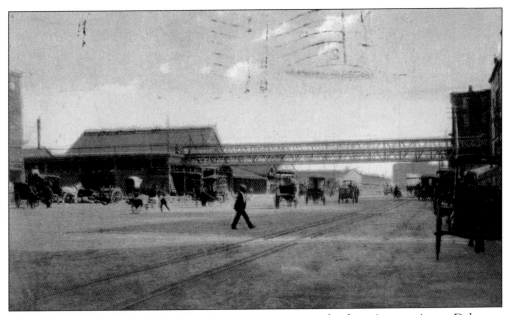

Who but the brave of heart would risk sauntering across such a busy intersection as Delaware Avenue at Chestnut Street during its midday rush?

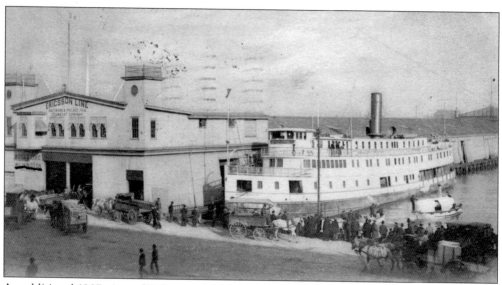

An additional 1907 view of Delaware Avenue at Chestnut Street features the Ericsson Line, also known as the Baltimore & Philadelphia Steamboat Co.

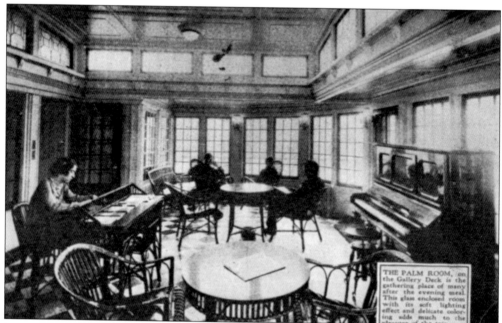

In 1929, a round-trip from Philadelphia to Baltimore via the Ericsson's steamboat *John Cadwalader* cost $4 (approximately $53 today). However, this view of its Palm Room reveals that its ambience was well worth the price.

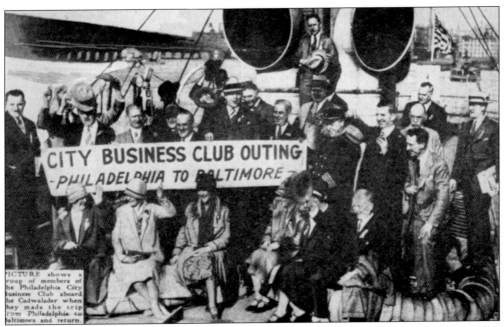

Gone are the days when members of organizations such as the Philadelphia City Business Club could find time from their daily travail to schedule a relaxing round-trip between Philadelphia and Baltimore. Such an outing must have been a great morale booster!

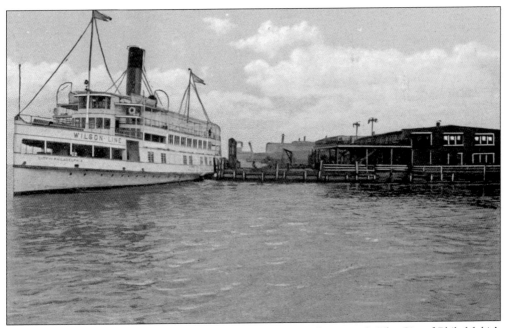

Delaware Avenue and Market Street was the site of the Wilson Line's *The City of Philadelphia*'s landing pier. The vessel was one of a large fleet that sailed from Philadelphia to Chester, Pennsylvania, and Wilmington, Delaware. The card was postmarked in 1936.

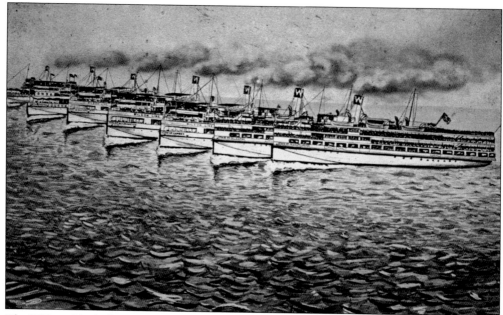

The Wilson Line's fleet had a total carrying capacity of 15,000 persons. It began operation in 1881 and ceased boarding passengers in 1961. Each year, between May 15 and September 15, the line also had daily sailings to Riverview Beach Park, a large amusement facility in Pennsville, New Jersey. This postcard is from 1924.

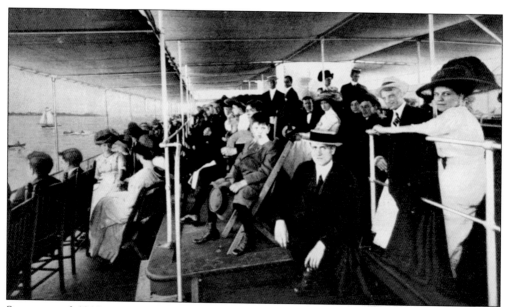

Seen around 1910, men sporting straw hats and women displaying their large bonnets sit in comfort within the enclosed deck aboard a Wilson Line vessel, anxiously waiting to disembark at Riverview Beach Park.

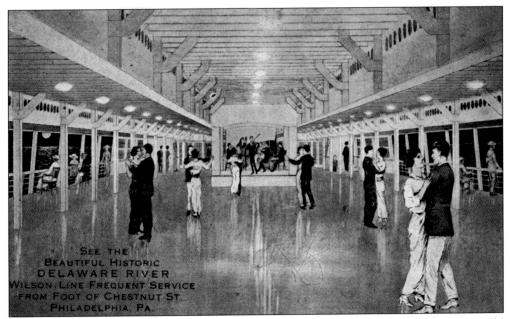

The larger of the Wilson Line boats were moored at the Chestnut Street pier. One could embark on a romantic moonlight cruise and spend a relaxing evening dancing to the rhythms of a live band.

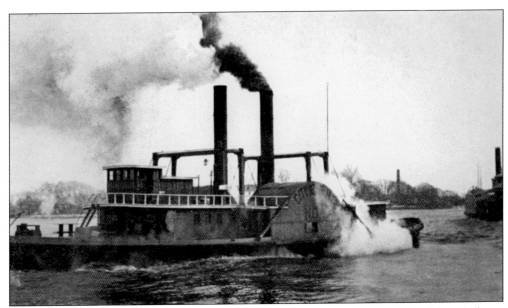

More utilitarian and much less romantic were the City of Philadelphia's steam-driven iceboats that patrolled the frigid waters of the Delaware River, clearing away floes for the ferries and larger shipping vessels. A Market Street ferry is seen on the extreme right of this view from 1907.

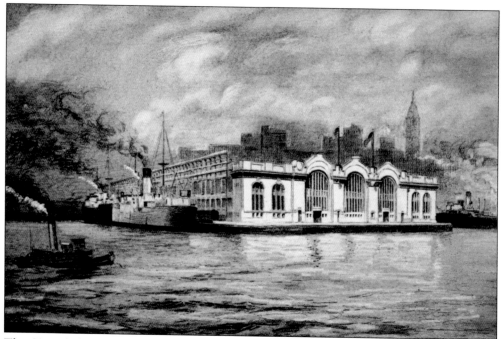

The City of Philadelphia established its Department of Wharves, Docks, and Ferries in 1907. The port consisted of 13 municipal piers, some able to accommodate four steamers that could unload their holds directly onto railroad cars waiting at the tracks on Delaware Avenue. This is an artist's rendition of one of the piers.

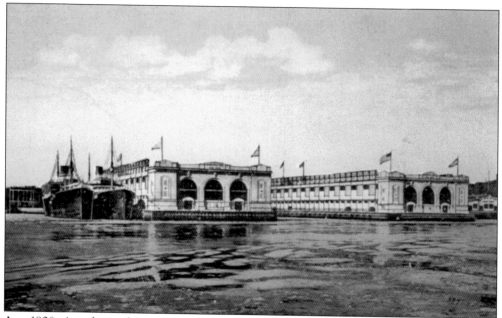

A c. 1920 view shows the municipal pier located at the foot of Queen and Catherine Streets. Unfortunately, the printer of this postcard could not mask the scummy, oily surface of the Delaware River waterway. This former municipal building is currently functioning as a commercial self-storage facility.

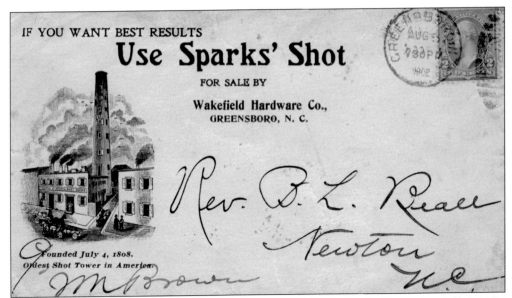

IF YOU WANT BEST RESULTS

Use Sparks' Shot

FOR SALE BY

Wakefield Hardware Co.,
GREENSBORO, N. C.

Founded July 4, 1808.
Oldest Shot Tower in America.

Rev. B. L. Reall
Newton
N.C.

In 1808, architect Thomas Sparks erected a tower located at 129–131 Carpenter Street, near the Delaware River, illustrated on this philatelic envelope postmarked 1902. Liquid lead was poured from the height of the 142-foot tower into a large receptacle of cold water, causing solidification and formation of the cascading spheroids into lead shot. During the War of 1812, Sparks received large purchase orders from the federal government to manufacture shot.

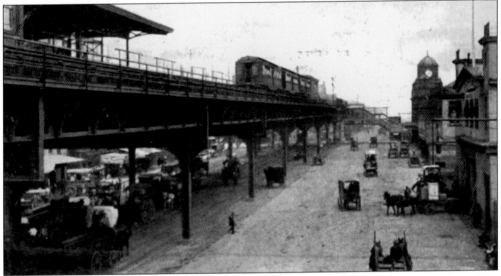

Philadelphia's capability for mass transportation was greatly enhanced in the first quarter of the 20th century through the construction of an elevated railway system, linking Center City to West Philadelphia. The terminus, viewed here, was located at Delaware Avenue and Market Street. The overhead stairway leading directly to the ferries is seen in the distance on the right.

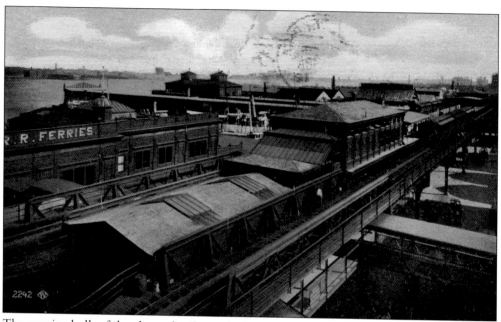

The massive hulk of the elevated railway platform virtually obscures an overhead view of the Market Street ferry terminal, seen in this postcard from 1912.

Stretching from Vine Street to South Street, Penn's Landing is a 10-block-long riverside park located at the site where William Penn first set foot upon his "greene country towne." In 1967, the City of Philadelphia began redevelopment of the forlorn docks, creating a recreational area complete with an amphitheater and walkways. The Benjamin Franklin Bridge can be seen in the background.

Five

HAPPENINGS AROUND WASHINGTON AND INDEPENDENCE SQUARES

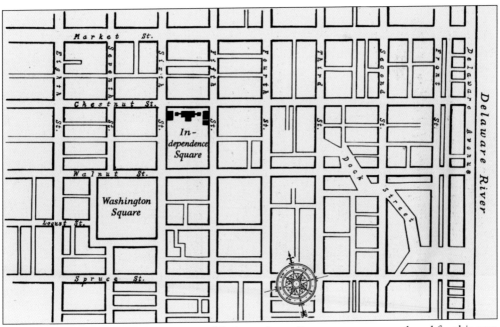

A simplified view of the Washington and Independence Squares area was produced for this map from 1927.

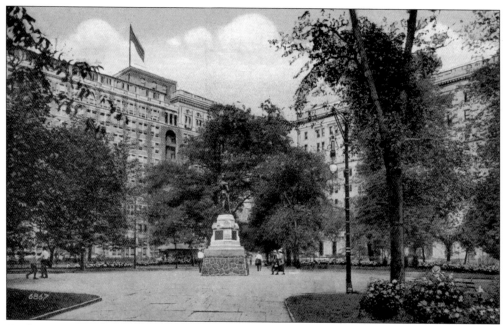

Washington Square, recorded in this c. 1930 postcard image, was utilized as a potter's field during the 18th century. It is bounded by Walnut, Sixth, and Seventh Streets. The Washington Grays Monument, a memento of the Civil War, was dedicated in 1908. It was removed in 1954 in order to refocus the square's theme solely on the Revolutionary War.

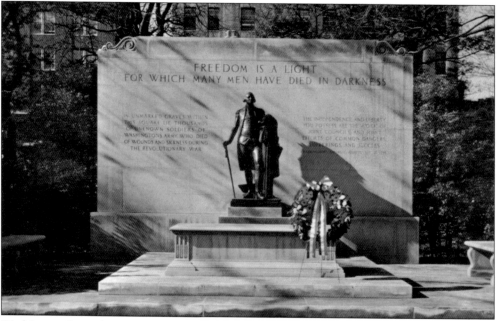

Washington Square's current centerpiece, a monument designated as the Tomb of the Unknown Revolutionary War Soldier, was designed by architect G. Edwin Brumbaugh and erected in 1954. A bronze cast of Houdon's statue of Washington stands tall as its central figure. The tomb holds the disinterred remains of a soldier buried when the square was a potter's field. It is unknown whether he was a Colonial or British soldier.

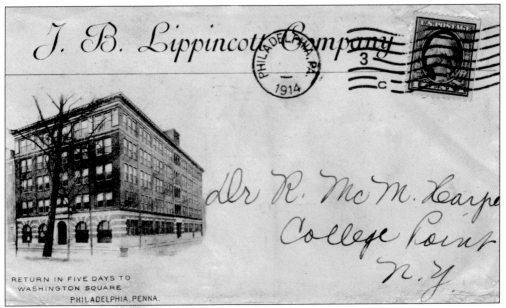

The J.B. Lippincott Company was founded in Philadelphia in 1836. Initially printing prayer books and Bibles, it gradually expanded into the publication of history texts, fiction, almanacs, and medical and law books. Seen on this envelope postmarked 1914, the building, located at 227 South Sixth Street, was designed by William Cresson Prichett Jr. and erected in 1900. It is now a condominium building.

The Orange Street Friends Meeting House, established as the meeting site for the southern district of Quakers whose territory included Moyamensing, Southwark, and Passyunk, was built in 1832 on the southwest corner of Washington Square on land obtained from the Penn family in 1774. In 1909, Wilmer Atkinson purchased the property for his Farm Journal Building. The meetinghouse was razed in 1911.

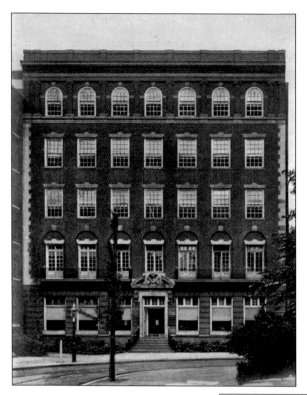

The Farm Journal Building, designed by Bunting and Shrigley, is located at 230–234 South Seventh Street, on the southwest corner of Washington Square. Its founder, Wilmer Atkinson, advertised that his publication, the *Farm Journal*, provided "no paid-for puffery; no quack medical advertisement; a deep and abiding interest in the welfare of all honest tillers of the soil," and he threatened "death to humbugs that prey upon farmers."

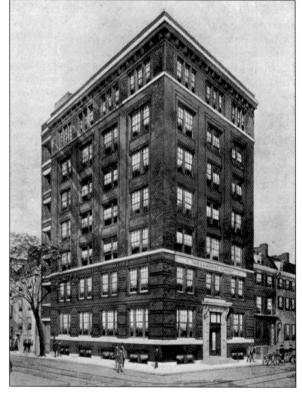

The W.B. Saunders Company, founded in 1888 by bookseller Walter Burns Saunders, was a major leader in the specialized publication of medical textbooks, journals, and periodicals. At its peak, the firm boasted 800 employees. The business was sold to CBS in 1968 and, in turn, to Harcourt Brace Jovanovich in 1986. The Saunders headquarters is seen in this c. 1910 view. It is now a condominium building.

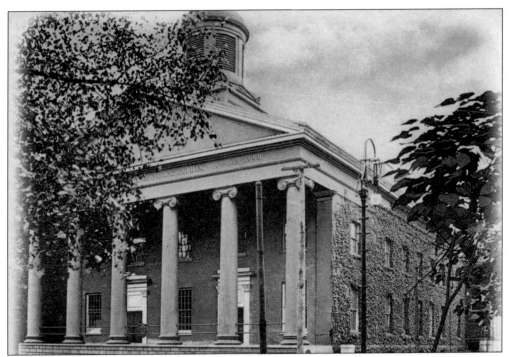

This postcard view from 1911 cannot begin to reflect the stately elegance of the First Presbyterian Church, established in 1822 on South Washington Square. Architect John Haviland, builder James Clark, and stonecutter John Struthers modeled their design upon an Ionic temple on the river Ilyssus near Athens. The church was occupied until 1928 and demolished in 1939.

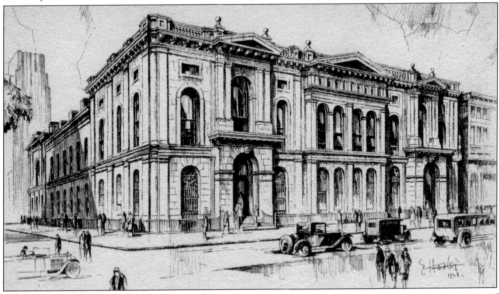

This 1928 view illustrates the Philadelphia Saving Fund Society, located at the intersection of West Washington Square, Seventh Street, and Walnut Street. Founded in 1816 as a benevolent institution, it had no stockholders. The building was designed in the Italianate style by architects Sloan and Hutton, the winners of an 1868 architects' competition. It has been renovated into an upscale restaurant.

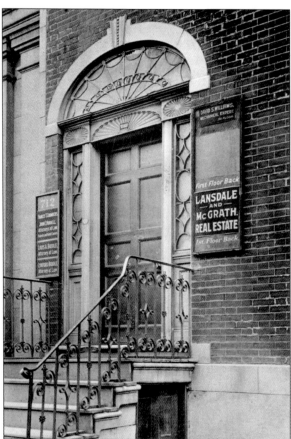

This house at 712 Walnut Street, adjacent to the Philadelphia Savings Fund Society building, remains standing today. Around 1915, it was the home office of lawyers and real estate agents.

Pennsylvania Hospital has been located at Eighth and Pine Streets since the laying of its cornerstone in 1755. Its stated mission promises that the hospital was founded "for the reception and cure of the sick poor." The first patients were admitted in 1756, and more wings were added as the institution continued to grow. This c. 1910 postcard illustrates the extent of the hospital property.

The Morris House is located at 225 South Eighth Street, between Walnut and Locust Streets. This historic colonial home, built in the Georgian style in 1787, has been renovated into a fashionable bed-and-breakfast. This is a c. 1915 postcard.

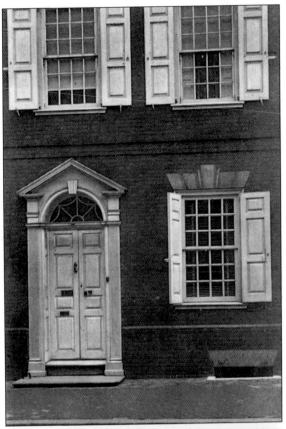

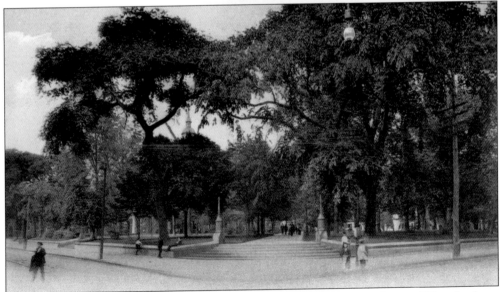

Independence Square is bounded by Fifth, Sixth, Walnut, and Chestnut Streets. When land was purchased in 1730, the area, which was close to the western boundaries of the city at that time, was first known as State House Yard. This c. 1910 view of Independence Square was taken from the corner of Sixth and Walnut Streets.

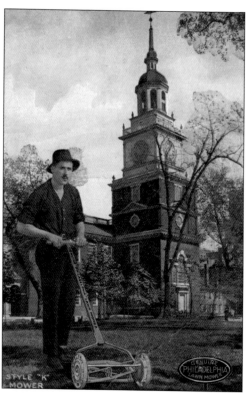

This is a classic advertising postcard from the Philadelphia Lawn Mower Company. The Style "K" mower was manufactured either "plain or with roller bearings," the model with a 16-inch blade costing $22 (equivalent to $534 today). In 1910, caretakers were responsible for cutting the grass in front of Independence Hall. Currently, National Park Service rangers perform the lawn maintenance.

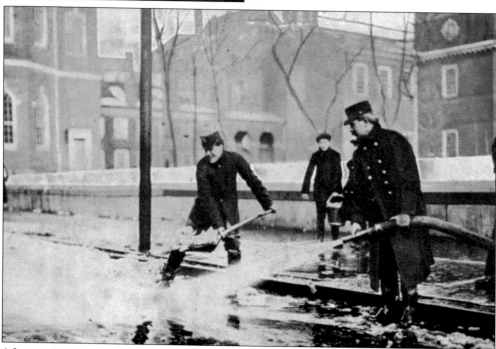

After a winter storm, city employees busily shovel snow and wash the cobblestone paving on Sixth Street, near Walnut Street, as captured on this card postmarked in 1911. The rear of Independence Hall is seen in the background.

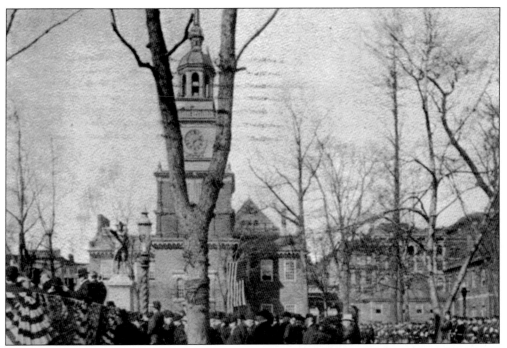

The statue honoring Commodore John Barry (1745–1803), father of the American Navy, was unveiled in Independence Square on March 16, 1907, amid splendid regalia. This card was posted one year later.

The buildings on Chestnut Street between Fifth and Sixth Streets were home to many types of financial institutions. The tall, ornate building, second from the left, was the office of the Pennsylvania Company for Insurances on Lives and Granting Annuities. This is a c. 1910 postcard.

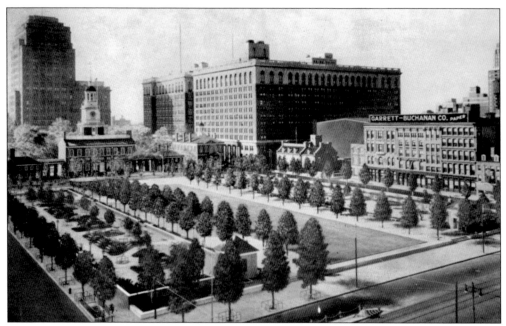

This c. 1952 view depicts an architect's master plan for the area between Chestnut, Market, Fifth, and Sixth Streets, after all of the buildings within that space had been cleared. The reverse of the card states, "This new approach to Independence Hall is the first step in a program to preserve our 'Cradle of Liberty' by surrounding it with public parks." Independence Mall was completed in 1969.

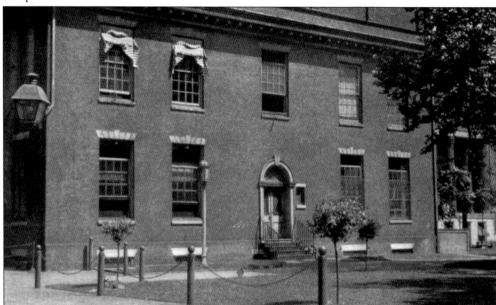

The American Philosophical Society was founded in 1743. Its headquarters, erected in 1789, is located on the Fifth Street side of Independence Square, just south of Chestnut Street. Since the days of Benjamin Franklin, the society's credo has been to promote useful knowledge in the sciences and humanities. The building is a repository of numerous important and priceless documents and portraits.

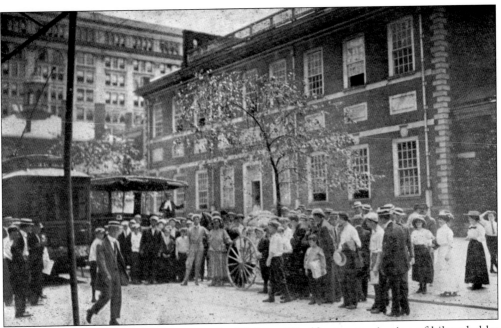

In the first decade of the 20th century, the Walking Woolfs, an organization of hikers led by Dwight Homer Woolf, "invaded" Philadelphia. While posing for a photograph in front of Independence Hall, the group brought the surrounding streetcar traffic to an abrupt halt.

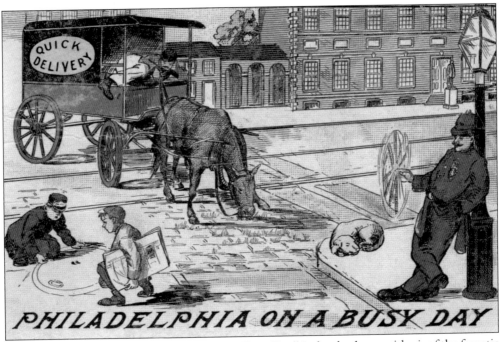

A cartoonist's sketch titled "Philadelphia on a Busy Day" is the absolute antithesis of the frenetic scene caused by the Walking Woolfs. This 1907 drawing characterizes the Chestnut Street side of Independence Hall as being a very lazy place.

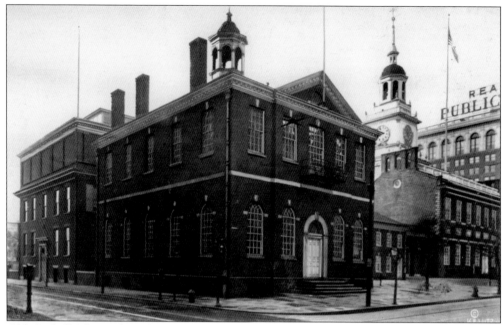

Old city hall is located on the southwest corner of Fifth and Chestnut Streets. The first sessions of the Supreme Court of the United States were held in the building between February 1791 and August 1800. The mayor, aldermen, and city council presided there until 1895. This postcard is from 1939.

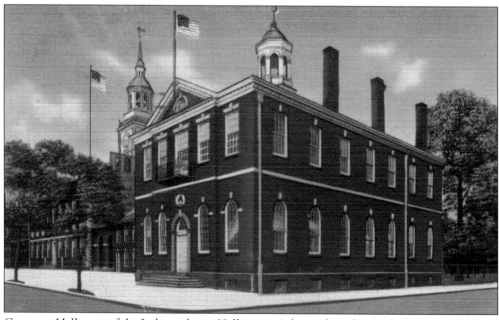

Congress Hall, part of the Independence Hall group, is located on the southeast corner of Sixth and Chestnut Streets. It served as the seat of Congress from December 1790 through May 1800. The House Chamber on the first floor accommodated 106 representatives from the original 13 states and the new states of Vermont, Kentucky, and Tennessee.

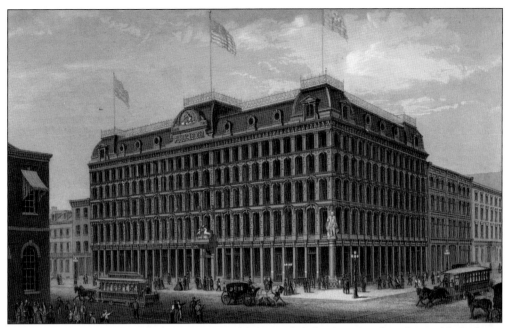

George William Childs (1829–1894) was a publisher and philanthropist who, along with Anthony J. Drexel, purchased the *Philadelphia Public Ledger*, a newspaper that had previously been a losing proposition. In 1866, the Public Ledger Building, seen in this view from 1868, was constructed on the southwest corner of Sixth and Chestnut Streets. After many significant changes, the *Public Ledger* was dubbed "the finest newspaper office in the country."

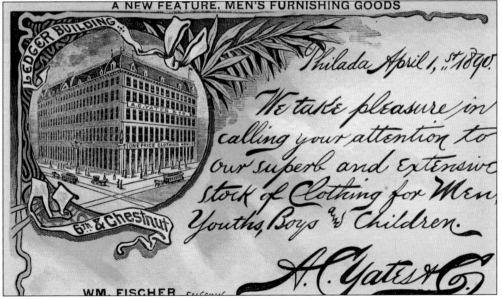

This is a lithographed advertisement printed on the reverse of a US government postal card, postmarked in 1890. A.C. Yates & Co.'s store was located in the Public Ledger Building, selling men's and boys' clothing. The bold signage across the facade insinuated that Yates was the building's primary occupant.

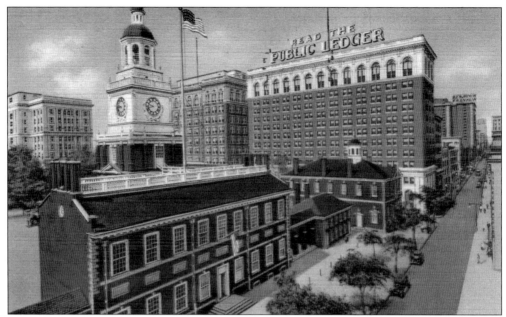

The old Public Ledger Building was demolished in 1924 and replaced by a more modern structure, designed in the Georgian Revival style by architect Horace Trumbauer. The newspaper eventually failed and, insolvent, ceased publication in 1942. The building can be seen across from the old city hall in this postcard from 1935.

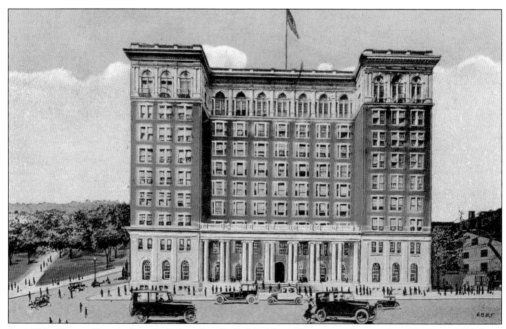

In 1891, Cyrus Curtis founded the Curtis Publishing Company, located at Sixth and Walnut Streets, opposite Independence Square. Seen in this postcard from 1921, the building was designed in the Beaux-Arts style by Edgar Seeler and erected in 1910. Its monthly publications included the *Ladies' Home Journal*, *Saturday Evening Post*, and *Country Gentleman*.

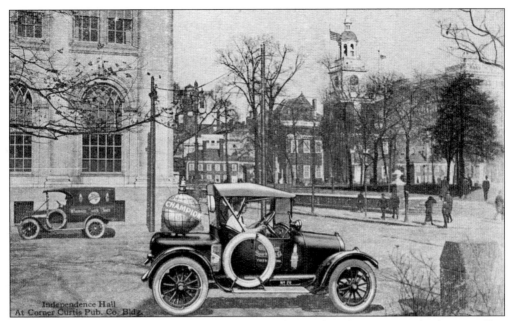

Although this early postcard is certainly an advertisement for Champion spark plugs, it offers a spectacular view of the corner of Sixth and Walnut Streets, with Independence Hall in the background and the Curtis Publishing Company building to the left.

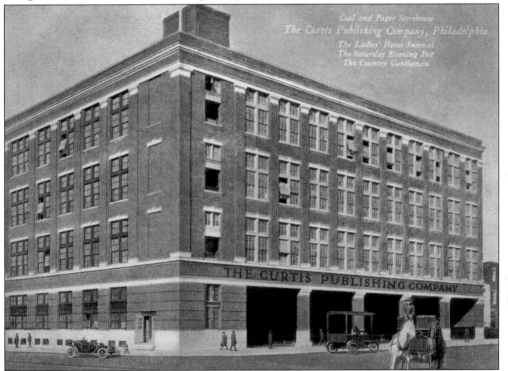

Another early postcard shows the Curtis Publishing Company's loading dock, located at the rear of its building on Sansom Street, between Sixth and Seventh Streets. This view was printed at a time when horse-drawn wagons were still utilized for deliveries.

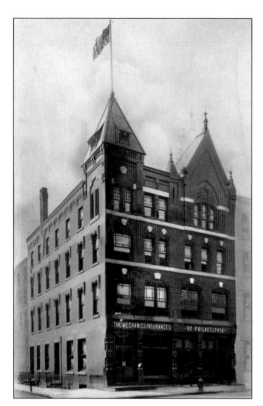

In the 1920s, insurance companies and insurance agencies populated many buildings on Walnut Street, from Sixth Street eastward toward Dock Street. The Mechanics Insurance Company, incorporated in 1854, was a purveyor of fire insurance. Seen in this card postmarked 1907, its building, now demolished, was located on the southwest corner of Fifth and Walnut Streets.

This 1950 postcard is a likeness of the home office of the Pennsylvania Fire Insurance Company, located at 508–510 Walnut Street. John Haviland designed the facade of 508 Walnut Street in 1838, and in 1902, Theophilus Chandler Jr. designed 510 Walnut Street and the central parapet. The building was demolished between 1971 and 1974, but its historic facade has been preserved.

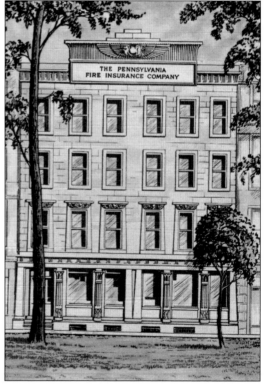

This c. 1910 view shows the Penn Mutual Life Insurance Company's original cast-iron building, located on the corner of Sixth and Walnut Streets.

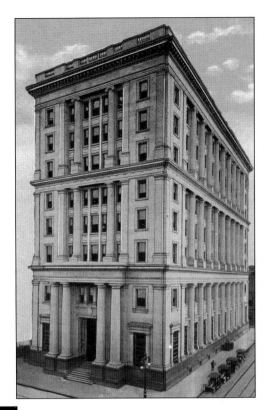

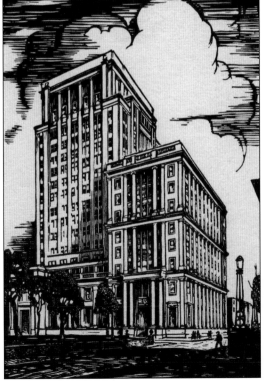

Designed by Edgar Viguers Seeler, a 16-story granite structure replaced the cast-iron Penn Mutual building in 1913. Its east side was altered in 1931 and again in 1969. A glass tower, built in the 1970s, retained the historic facade of the Pennsylvania Fire Insurance Company. This woodcut by Charles Reed Gardner illustrates the 16-story addition to the existing structure.

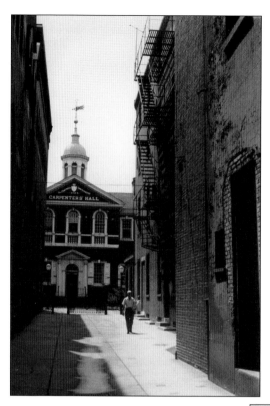

Dwarfed by numerous taller buildings, Carpenters' Hall was literally hidden within an alley, only 14 feet wide and less than 125 feet long. This photograph was taken in 1955, prior to demolition of the surrounding structures in preparation for the beautification of Independence National Historical Park. The building is still owned by the Carpenters' Company and remains the country's oldest existing trade guild.

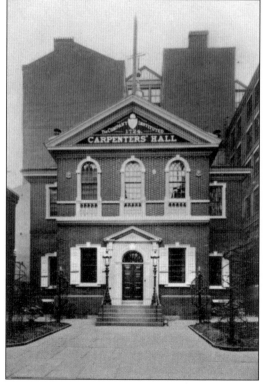

This postcard from 1905 affords a closer look at Carpenters' Hall, located between Third and Fourth Streets, just south of Chestnut Street. Built between 1770 and 1774, the historic edifice was designed in the Georgian style by architect Robert Smith and added to the National Register of Historic Places in 1970.

Six

LITTLE STREETS,
BIG DOINGS

The diminutive Camac Street has officially been dubbed "the Avenue of the Artists." Photographed around 1920 by Alfred Hand, the Poor Richard Club was located at 239–241 South Camac Street. The studio of iconic photographer William Rau was situated directly across the cobblestoned passageway. (Courtesy of the Library Company of Philadelphia.)

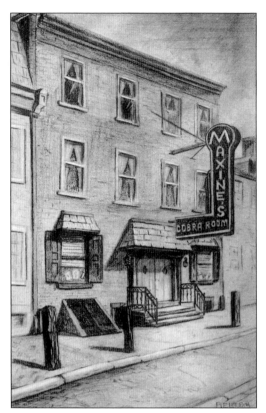

D. Beetem's sketch shows Maxine's Cobra Room, located at 243–245 South Camac Street. Opened by owner Ed King during the Prohibition era, the restaurant was rumored to be under the scrutiny of the Office of Strategic Services because of the nature of its clientele. In the 1950s, men were expected to wear ties and jackets. By the 1970s, Maxine's was considered "just another seedy place."

The Plastic Club, located at 247 South Camac Street, is still an active art studio and gallery. One of the oldest women's art organizations in the United States, it moved to its Camac Street address in the early 1900s. Between 1909 and 1940, the club was known for its exhibits of modernist art and its involvement in Philadelphia's progressive art community.

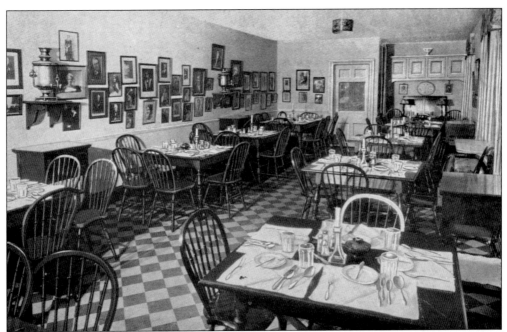

The Charlotte Cushman Club, located at 239 South Camac Street, was formed in 1907 for unaccompanied actresses working in the Philadelphia theater district in need of inexpensive and safe lodgings. Although not a member, the great Cushman, a well-known New York actress who gave her final performance in 1874, was the namesake for the club. This is a 1930s postcard view of the club's cozy dining room.

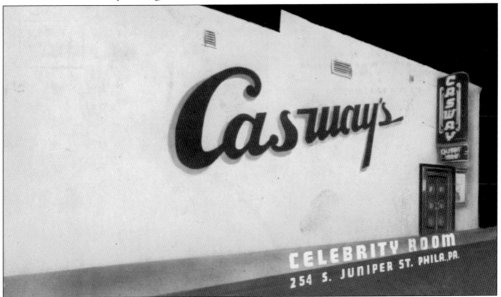

Casway's Celebrity Room was tucked away at 254 South Juniper Street, between Locust and Spruce, Broad, and Thirteenth Streets. The establishment proclaimed, "Nowhere in America will you find better food and drinks, smarter entertainment and a more beautiful setting and more for your money." Its exterior wall brandished a garish advertisement, but Casway's is now gone, and the property is currently a parking lot.

The Philadelphia Ethical Society's stated goals are to seek wisdom, nurture compassion, and stoke humanist inspiration. Around 1905, the society's home office was located on the corner of Spruce and Juniper Streets, across from Casway's Celebrity Room. The site is now also a parking lot. The society has relocated to Philadelphia's Rittenhouse Square area.

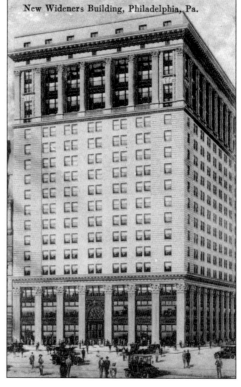

The Widener Building's main address is One South Penn Square, facing city hall. Its side address is 1331–1337 Chestnut Street, and its virtual location is 50–98 South Juniper Street. Designed by architect Horace Trumbauer, the building was erected in 1914. In 1937, alterations were made to accommodate local radio station WFIL. Over the years, additional renovations have upgraded the property.

At the time of this writing, Drury Street, located between Juniper and Thirteenth Streets, below Chestnut Street, was under heavy construction, and many of its old buildings were being replaced by modern structures. In the midst of this hubbub was McGillin's Olde Ale House, at 1312 Drury Street. The oldest continuously operating tavern in Philadelphia, McGillin's was opened in 1860, the year that Lincoln was first elected president.

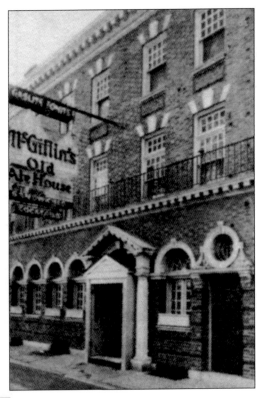

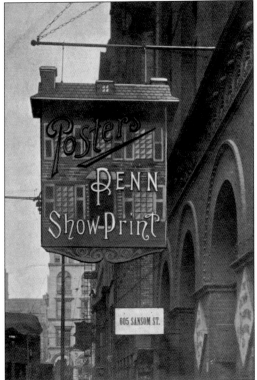

Sansom Street is a narrow but important Philadelphia thoroughfare, located between Walnut and Chestnut Streets. This advertising postcard showcases a business that was situated at 605 Sansom Street. The next block of Sansom Street, between Seventh and Eighth Streets, has long been known as Jewelers' Row. The street was named for William Sampson, an early-18th-century land developer.

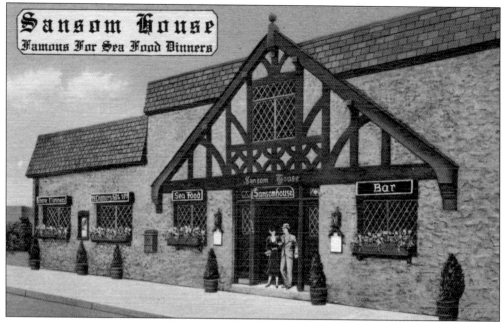

The Sansom House was located at 1302–1304 Sansom Street. This c. 1930 depiction shows the restaurant while in its heyday. It claimed to be the oldest German American restaurant in America. Specializing in seafood platters, it boasted "ninety-nine dinners to choose from."

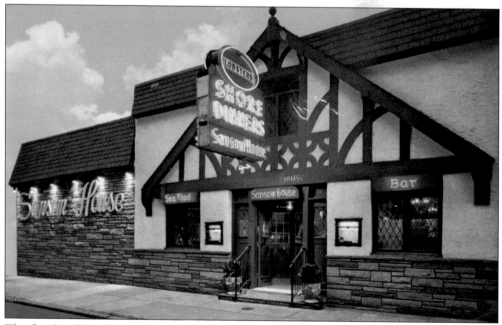

The facade of the Sansom House was altered at a somewhat later date. The windows to the left of the front door were bricked over, and a large neon sign was installed. This building no longer exists.

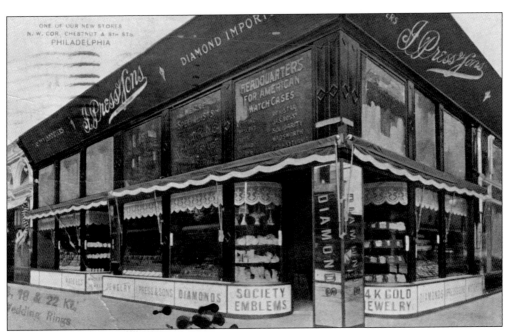

J. Press & Sons was a jeweler located on the northwest corner of Eighth and Chestnut Streets, adjacent to Jeweler's Row, as seen in this 1912 view. A preprinted message on the reverse of the card reads, "Look in the windows of this Jewelry store tomorrow. I think you will see just what we were talking about. The price surprised me." The corner is now a parking lot.

Clinton Street is a small, pleasant residential street only two blocks long, between Ninth and Eleventh Streets and Spruce and Pine Streets. A branch of the United Service Club, organized in 1917 to aid enlisted men in the US armed forces, was located on a corner property at 901 Clinton Street. The building has been restored, apparently as a private residence.

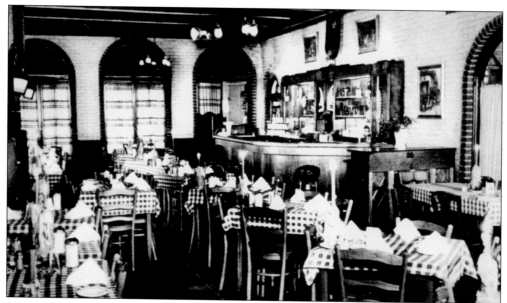

Around 1940, the Forrest Restaurant and Bar was situated on a small, quiet, shaded street at 204–206 South Quince Street, between Walnut and Locust Streets and Eleventh and Twelfth Streets. The checkered tablecloths and cloth napkins of the Forrest's English Room bespeak a wholesome, friendly atmosphere.

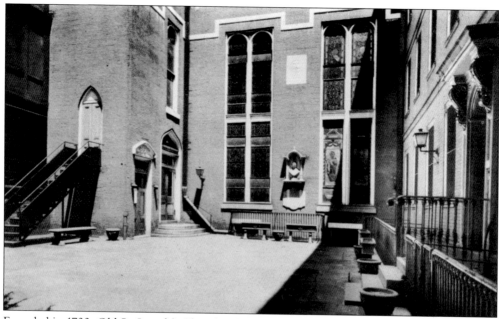

Founded in 1733, Old St. Joseph's Church is located at 321 Willings Alley, a tiny street located near South Third Street and parallel to Walnut Street. Prior to a dispensation granted by the Pennsylvania Provincial Assembly, it was the only church where English-speaking people could celebrate Mass in public. Built in 1839, the current house of worship is the third Roman Catholic church erected on that site.

Seven

NORTH OF SOUTH STREET

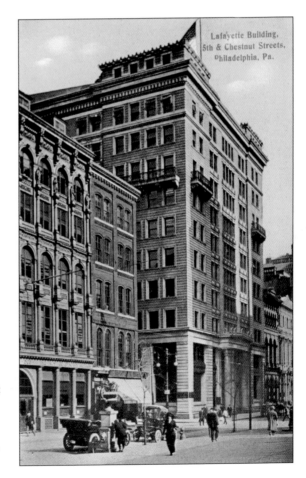

Fifth Street at Chestnut Street is certainly a busy intersection in this 1913 view. Located on its northeast corner, the Lafayette Building, an 11-story high-rise just down the street from Independence Hall, towers above the rest. Almost 100 years after the publication of this postcard, the Lafayette Building was converted into the luxury Hotel Monaco.

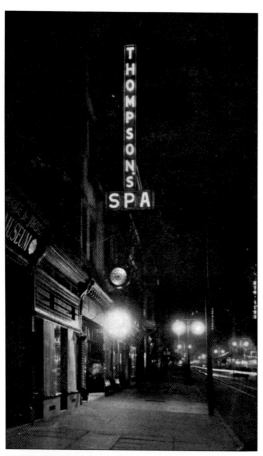

This is a c. 1910 nighttime view of Thompson's Spa, "the home of Thompson's Grape Juice," located at 712 Chestnut Street. The south side of the 700 block of Chestnut Street still contains many historic buildings that have been converted for commercial use. The current occupant of 712 Chestnut Street is, coincidentally, a nail salon and spa facility.

A 1911 interior view of Thompson's establishment does not quite fit the modern-day definition of the word "spa."

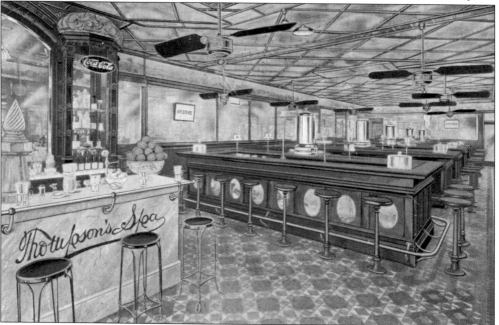

Guy's Hotel, seen in this 1913 postcard, was located on the northeast corner of Seventh and Chestnut Streets, one block from Independence Hall. Well celebrated as a drinking establishment, it was advertised as being on the European plan—that is, food and beverages were not included in the cost of lodging. The hotel was demolished, and a multistory office building now stands on this corner.

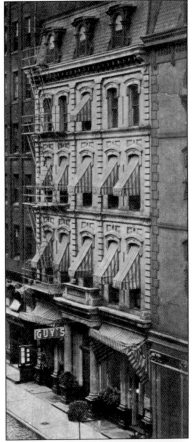

The post-Victorian-era Green's Hotel was located at 729–735 Chestnut Street. It boasted 255 rooms and "all modern improvements, elevators, baths, etc." In 1899, the daily room rate was $1 (equivalent to about $27 in today's currency—still a bargain). The postcard was dated 23 years prior to the hotel's demolition in 1934. A multistory parking garage now occupies this space.

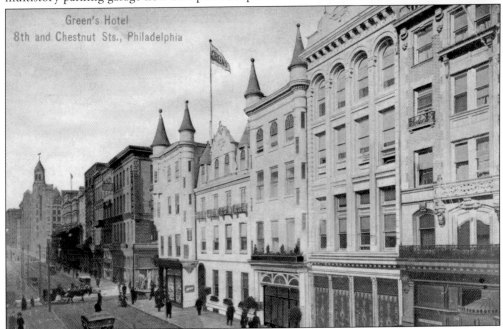

Green's Hotel
8th and Chestnut Sts., Philadelphia

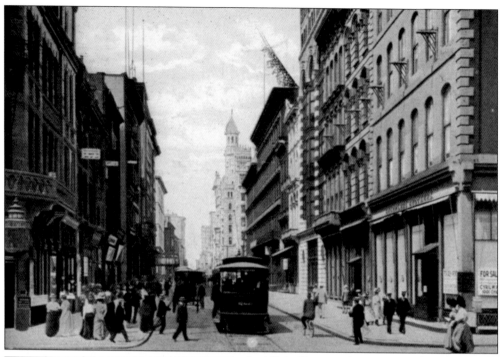

In 1906, Chestnut Street, west of Eighth Street, teems with pedestrian traffic.

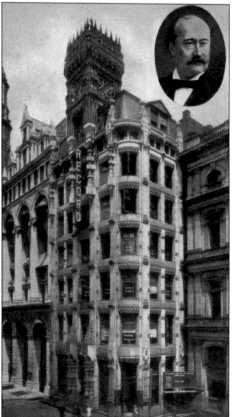

The *Philadelphia Record*, whose building is seen in this postcard from 1905, was founded in 1877. Located at Ninth and Chestnut Streets, it published a daily newspaper until 1947, when it finally succumbed to competition and was sold to the *Philadelphia Bulletin*. The inset shows a portrait of the *Record*'s founder, William M. Singerly, whose obituary states that he died of heart disease in 1898 while lying in bed smoking a cigar.

The Banks Business College was a storefront affair in 1914. Situated at 1016 Chestnut Street, the school taught basic secretarial skills, including the Pitman method of shorthand. The entire south side of this block is now a Thomas Jefferson University facility.

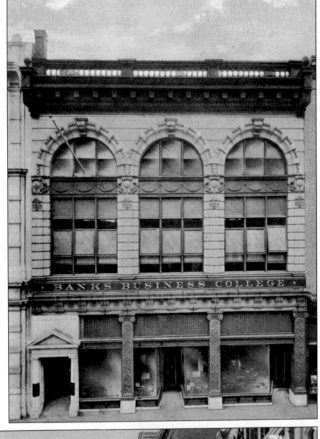

The caption of this 1914 postcard view of Chestnut Street incorrectly states that the image was taken by someone looking eastward from Eleventh Street. In actuality, the photographer was facing east from Twelfth Street, since Bellak's Piano Store was located at 1129 Chestnut Street.

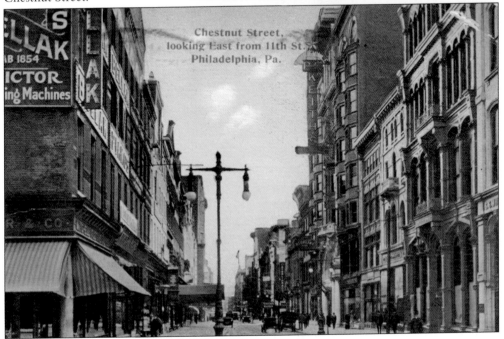

Chestnut Street, looking East from 11th St. Philadelphia, Pa.

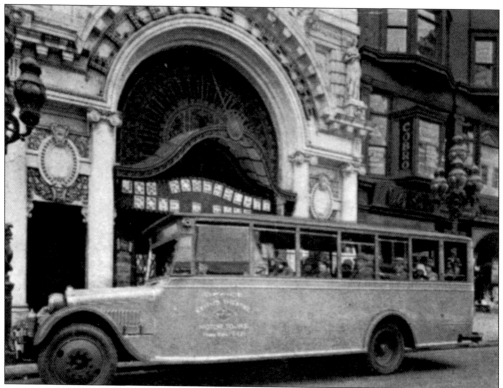

The front entrance of B.F. Keith's "Million Dollar" Theatre, located at 1116 Chestnut Street, appears somewhat narrow. This was, however, an illusion, since its auditorium was 118 feet wide and one full block deep, with a seating capacity of 2,273. The Gray Line Motor Tours, circa 1924, departed from in front of Keith's Theatre "every day in the year, every hour on the hour."

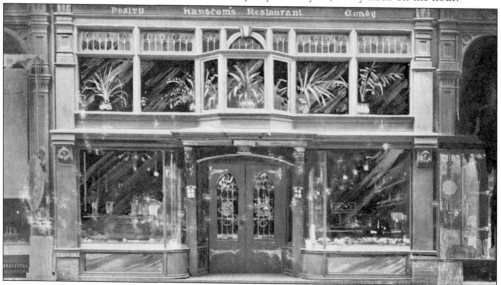

This postcard from 1904 captures a view of the exterior of Hanscom's Restaurant. Located at 1119 Chestnut Street, it was just across the street from Keith's Theatre. Hanscom's chain of restaurants and bakeries went into bankruptcy in 1984, after 101 years in business.

Oppenheim, Collins & Co. was located at 1207 Chestnut Street, although this address corresponds to the entrance at the lower right of the building. The reverse of this postcard from 1908 states, "When in Philadelphia, it will interest you to visit the exclusive Woman's Shop—where you'll find the most intensely interesting display of distinctive Outergarments to be seen anywhere." Currently, the store located at this site sells women's apparel.

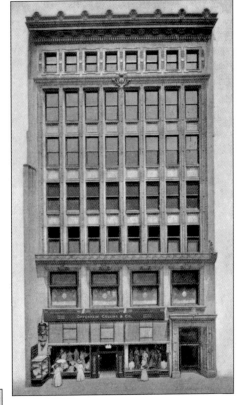

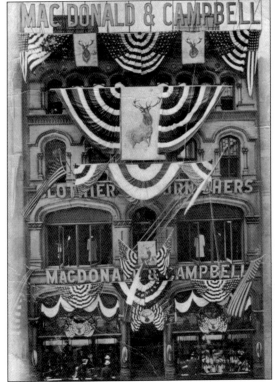

In 1907, the Benevolent and Protective Order of Elks descended on Philadelphia for its annual convention. MacDonald & Campbell, located at 1334–1336 Chestnut Street, garishly bedecked its entire facade with patriotic banners and Elks insignias. The store advertised its apparel as the "best ready to wear men's clothes in America."

The first medical school class of the Thomas Jefferson Medical College, established in 1824, graduated in 1826. Since that time, the university has undergone enormous growth. This postcard, copyrighted in 1935, shows the Jefferson Medical College and Curtis Clinic, located between Tenth and Eleventh Streets on Walnut Street. Designed by architect Horace Trumbauer, it was built in 1931 on the site of the former (1898) medical college.

The Western Savings Fund Society of Philadelphia bank was located on the southwest corner of Tenth and Walnut Streets. The bank's original facade, designed in 1887 by architect James Hamilton Windrim, was altered between 1902 and 1909. The building was demolished in 1967, and the Orlowitz Residence Hall of Jefferson University was erected on that site.

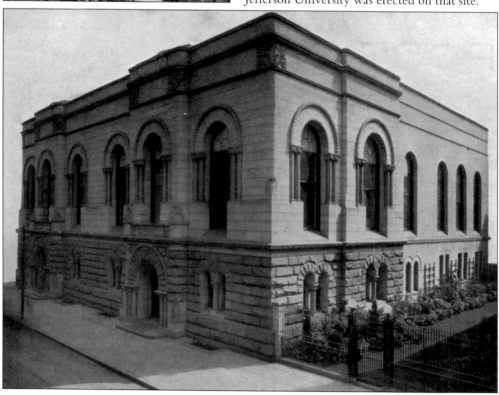

Dr. Samuel Stockton White (1822–1879) founded the S.S. White Tooth Factory in 1844. A great innovator of porcelain dental prostheses and early gold filling material, he also developed the first all–metal–frame dental chair in 1871. In need of larger quarters, the company relocated in 1896. Seen in this postcard dated 1910, the White Building, located at 211–217 South Twelfth Street, remains today.

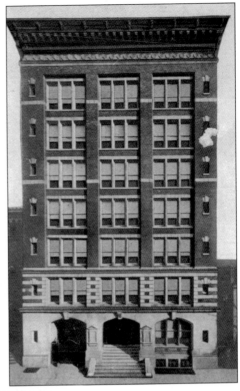

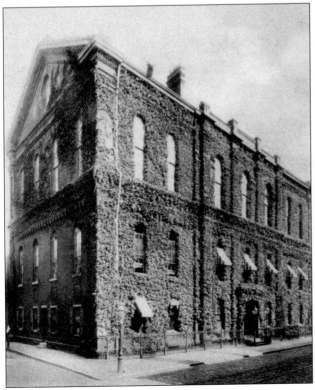

This 1920 postcard shows the ivy-covered exterior of the branch of the Free Library of Philadelphia that was located on the northeast corner of Thirteenth and Walnut Streets. A multistory office building now occupies the site.

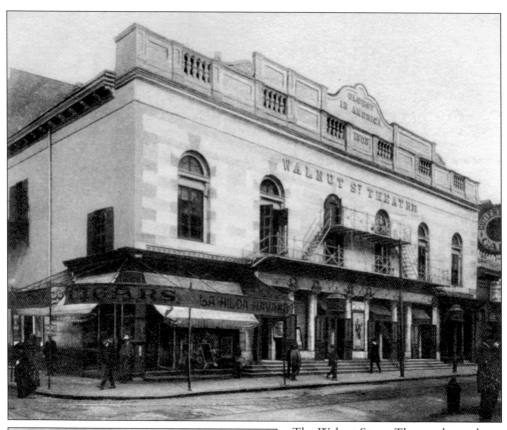

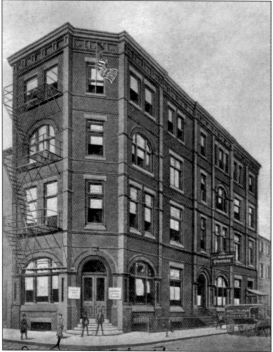

The Walnut Street Theatre, located at Ninth and Walnut Streets since 1809, is the oldest theater building in America. Morphing from an initial circus-like atmosphere into that of a legitimate theater, it has undergone a series of major renovations, including those designed by architect John Haviland in 1828. The cigar store on the corner, seen in this very early postcard from 1901, has long since been removed.

In 1911, the John T. Palmer Company occupied the entire building at Fifth and Locust Streets. It advertised itself as "The Home of Good Printing." The area is now strictly residential.

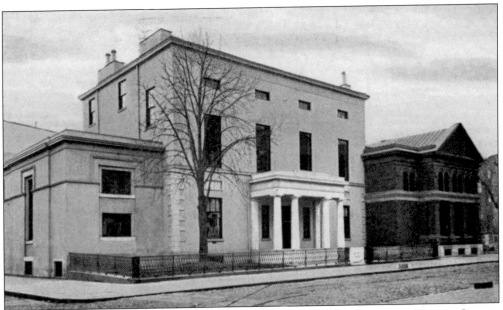

When he purchased the mansion on the southwest corner of Thirteenth and Locust Streets, Gen. Robert Patterson, a merchant and Civil War officer, never foresaw that his residence would eventually become the home of the Historical Society of Pennsylvania, seen in this view from 1904. The historical society demolished the mansion between 1905 and 1909.

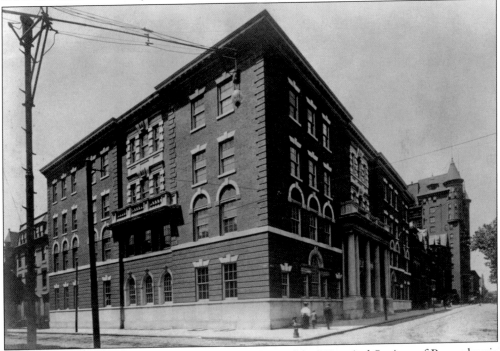

This c. 1915 view shows the new fireproof building of the Historical Society of Pennsylvania that replaced the Patterson mansion, seen in the preceding image. Designed by architect Addison Hutton, it was dedicated in 1910. The society's extensive historic collections contain priceless Pennsylvania regional printed items and manuscripts.

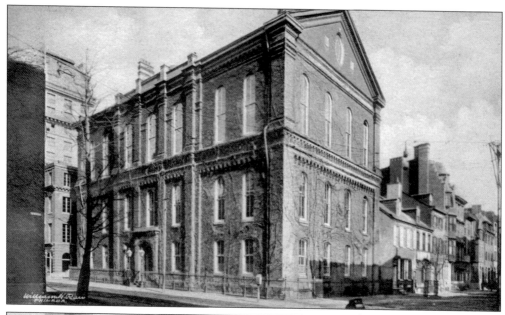

Seen in this card from 1939 is another of the many branches of the Free Library of Philadelphia, this one located on the northeast corner of Thirteenth and Locust Streets, kitty-corner to the historical society's building. The site is now a parking lot.

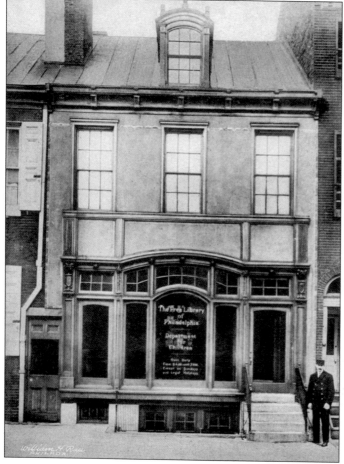

The Children's Department of the Free Library of Philadelphia was situated at 1233 Locust Street, just down the street from its adult branch.

The Hotel Lincoln was located at 1222 Locust Street, directly across the street from the Free Library's Children's Department. Seen in this 1906 view, it was also known as the YWCA League Branch and Business Women's Christian League Hotel. The hotel advertised that its accommodations included "bath or running water." The building is currently boarded up, heavily damaged by a fire in the early 2000s.

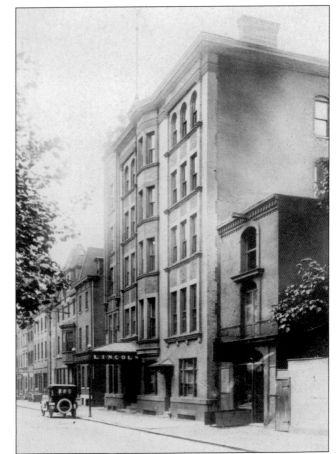

Otto Landenberger's cigar store and tavern was located on the northwest corner of Twelfth and Locust Streets, as appreciated in this view from 1910. Today, the building's exterior remains intact and virtually unchanged.

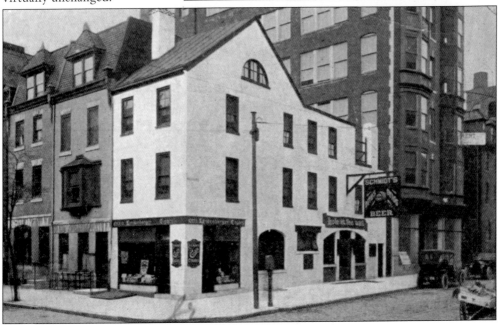

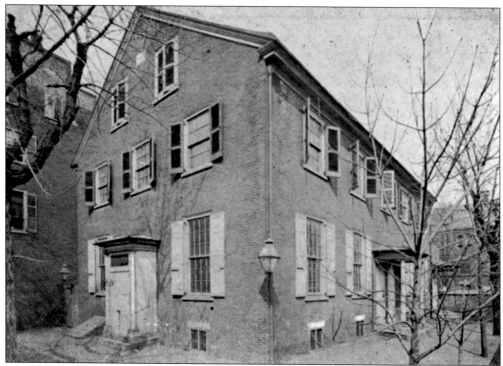

The Spruce Street Meeting House, seen in this postcard view from 1905, was located at South Ninth and Spruce Streets, close to the Pennsylvania Hospital.

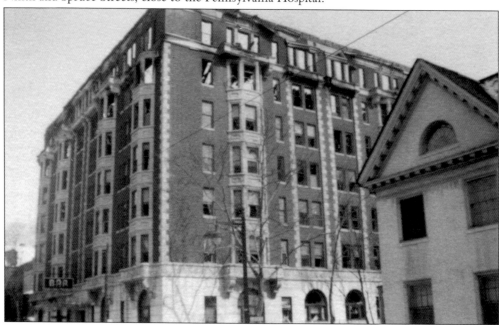

The Clinton Hotel and Apartments on Tenth Street, below Spruce Street, was advertised as having the "largest hotel rooms in Philadelphia." The 200-room structure included amenities like garage facilities and a roof garden. Dated February 29, 1952, this postcard graphically displays the ruins of the hotel after a devastating fire.

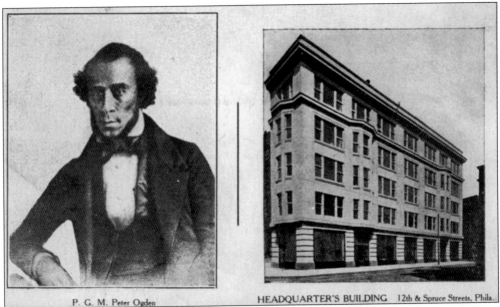

P. G. M. Peter Ogden

HEADQUARTER'S BUILDING 12th & Spruce Streets, Phila.

This dual postcard portrays Peter Ogden, founder of the Grand United Order of (Negro) Odd Fellows in America in 1843, and the organization's national headquarters, located at Twelfth and Spruce Streets. In 1906, the *Philadelphia Inquirer* reported that the five-story structure would be erected at a cost of $100,000 and would be "the largest occupied by a negro organization in the United States." The building still stands.

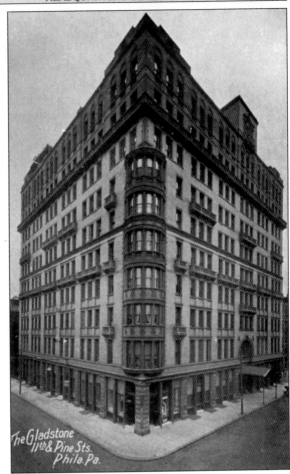

The Gladstone Hotel, designed around 1890 by T.P. Chandler, founder of the Department of Architecture at the University of Pennsylvania, was situated on the quiet northwest corner of Eleventh and Pine Streets. As it deteriorated with age, the gruesome building came into conflict with the beauty of the surrounding 18th-century colonial row homes, and thus was demolished in 1971. A lovely city park was planted on the site.

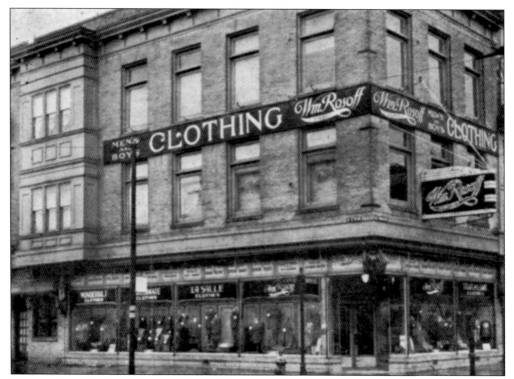

William Rosoff called his establishment the House of Reliability. In the 1920s, it was located on the southwest corner of Fifth and South Streets, selling men's and boys' apparel. South Street was a busy retail garment district that flourished until the 1950s. In 1963, the street was immortalized as the place "where all the hippies meet" in the song "South Street" by the Orlons.

Morris Rosenbaum was a "travel agent" for the North German Lloyd Steamship Company. This postcard from 1911 advertises the interior view of his high-ceilinged office at 605 South Third Street, near South Street. By 1918, the North German Lloyd Company was left with only smaller sailing vessels. Having lost its previous fleet of cruise ships to the spoils of World War I probably greatly affected Rosenbaum's business as well.

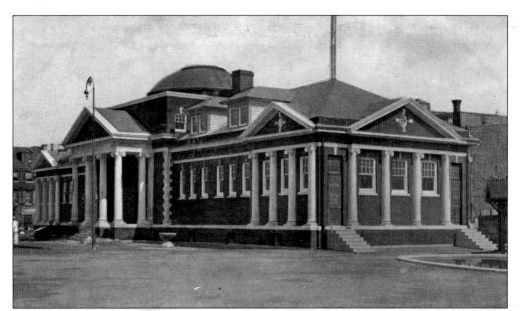

The recreation center of Starr Garden Park is seen in this c. 1915 postcard. The park itself encompasses a full city block between Sixth and Seventh Streets, on the south side of Lombard Street. The reverse of the card proclaims, "The playground keeps the child off the car tracks, and thus out of the hospital." The park remains a vital center for Society Hill youth.

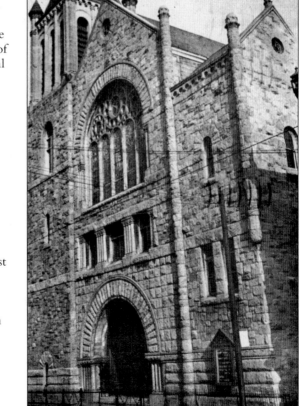

The Mother Bethel African Methodist Episcopal Church, located near the Starr Garden Park, is the oldest church owned and organized by African Americans. It was founded in 1794 by African American minister Richard Allen. The current church, seen in this postcard from 1944, was constructed between 1888 and 1890. It has been designated as a National Historic Landmark.

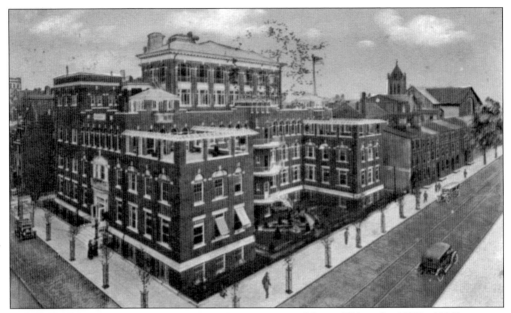

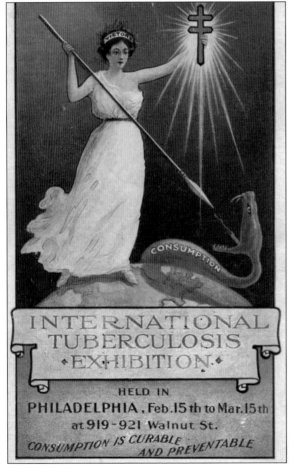

Henry Phipps Jr. (1839–1930) was a philanthropist and entrepreneur who funded the Phipps Institute for the study, treatment, and prevention of tuberculosis. In 1913, he erected and dedicated a building located at Seventh and South Streets, having selected the University of Pennsylvania to further his work. In 1960, the institute was moved to the University of Pennsylvania's new Medical Research Building in West Philadelphia.

Tuberculosis was a major and grave health concern in the first quarter of the 20th century. In 1913, a study published by the Phipps Institute concluded that there were 2,849 reported deaths due to tuberculosis in Philadelphia's Fifth Ward between 1863 and 1909 and that a large percentage of these deaths had occurred in a relatively small number of the houses. This c. 1910 postcard stresses the crusade for its cure.

Eight

HEADING TOWARD THE SOUTH OF THE CITY

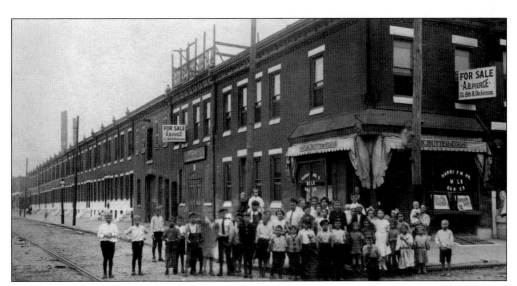

In 1907, an itinerant commercial postcard photographer snapped this shot of the crowd that he had gathered at the corner of the 2000 block of South Second Street, south of McKean Street. The store to its rear sold butter and eggs. Before supermarkets became popular, such specialty stores were common. Often, the stores' owners lived in the dwellings above their businesses.

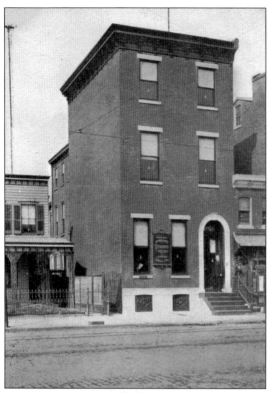

Moyamensing Avenue runs in a diagonal direction across South Philadelphia, from Fifth and Jackson Streets to Packer Avenue. The German Lutheran Seaman's Home was located at 1402 East Moyamensing Avenue, near the intersection of Broad Street and Oregon Avenue. The style of homes seen in this card from 1912 indicated that the neighborhood was already aging. *Moyamensing* is the Lenni-Lenape (Delaware) word for "place of pigeon droppings," or "unclean."

The building for the Navy Young Men's Christian Association was situated at the intersection of Thirteenth Street, Shunk Street, and Moyamensing Avenue, not very far from the Philadelphia Naval Shipyard. The postcard is from 1917.

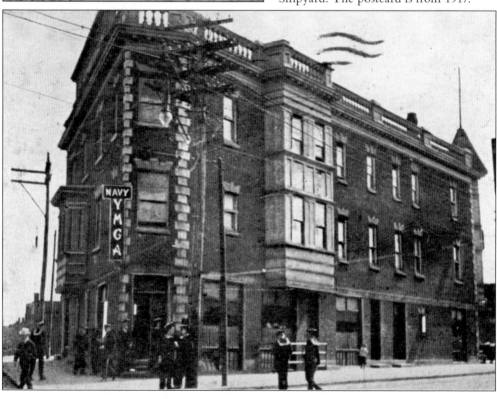

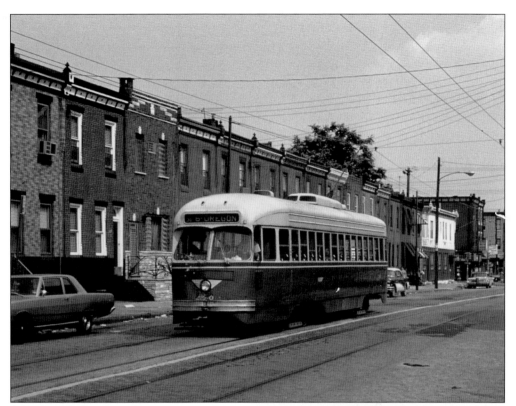

A Route 50 electric trolley was photographed traveling west on Snyder Avenue, between Fifth and Sixth Streets, in this 1960s view. The trolley would continue its run, heading southward toward its eventual terminus at Sixth Street and Oregon Avenue.

Rev. Wm McNally
Pastor Mizph Presby. Church
8th & Wolf Sts Phila Pa

The Meadow Presbyterian Church, established in 1855 for the children of dairy farmers, was initially a Sabbath school located in the "meadows" on League Island Road. Moving to Eighth and Wolf Streets in 1906, it changed its name to the Mizpah Presbyterian Church. Rev. William McNally (pictured) was pastor for a year, until he announced his resignation after accepting a new position in Nova Scotia.

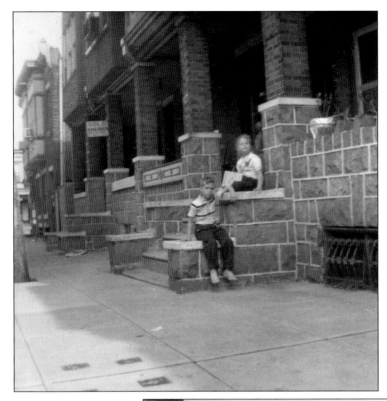

The 300 block of Roseberry Street, located between Third and Fourth Streets and Ritner and Porter Streets, is typical of the South Philadelphia row house design, including a small open-air porch. Seated on the step in front of 314 Roseberry Street are the author's two young cousins, Nina and Barry Farber. This photograph was snapped in the late 1950s.

The annual New Year's Day Mummers Parade is a Philadelphia tradition. This photograph was taken in 1957 at the corner of South Third and Ritner Streets as a fancy division of mummers bows to its audience.

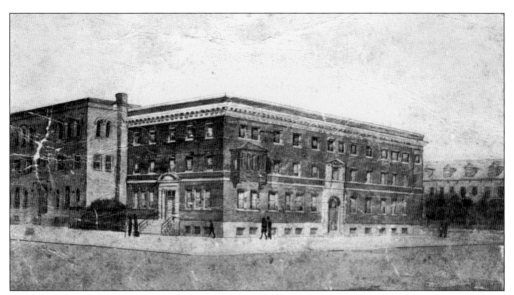

Directly across the street from the row homes seen in the preceding image is the parish of Our Lady of Mount Carmel, located on the east side of Third Street, between Ritner and Wolf Streets. Overseen by Carmelite nuns, the church was founded in 1896 and constructed in 1922. The postcard, date unknown, illustrates architect Paul Monaghan's proposed plan for the church's convent building to house its Sisters of Mercy.

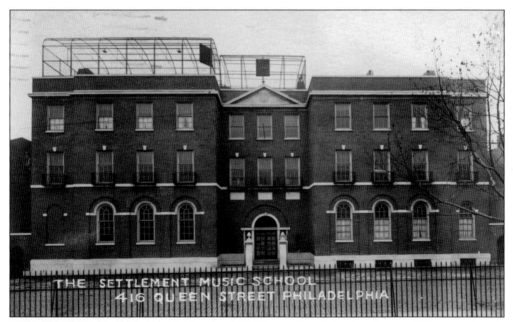

The Settlement Music School, located at 416 Queen Street, in the Queen Village section, is seen in this postcard from 1934. Founded in 1908, it remains the largest community school of the arts in the United States. More than 300,000 students have matriculated through its various music programs and activities, and it boasts that many of the country's major orchestra members received their initial training at the school.

Frank and Rose Snock opened their first oyster house in 1912 at Front and South Streets. After an initial move in 1918, they moved again in 1931 to a refurbished ice cream parlor, located at 523 South Eighth Street, as seen in this c. 1940 postcard. In 1975, the restaurant was again relocated to Queen Village on South Second Street. Snockey's remains a family-owned business.

The busy Southwark Branch of the Free Library of Philadelphia was located at 1108 South Fifth Street, near Ellsworth Street. Dedicated in 1912 and paid for with a Carnegie Corporation grant, the library served its densely populated neighborhood of South Philadelphia for many years. The building remains as a senior center.

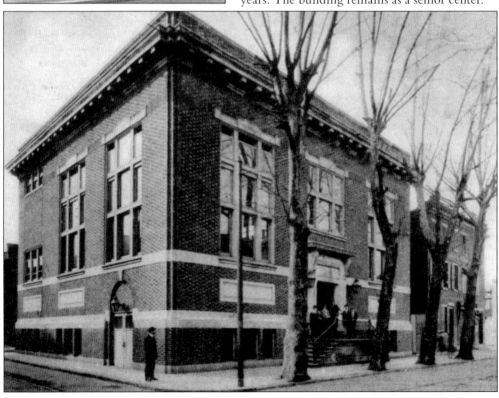

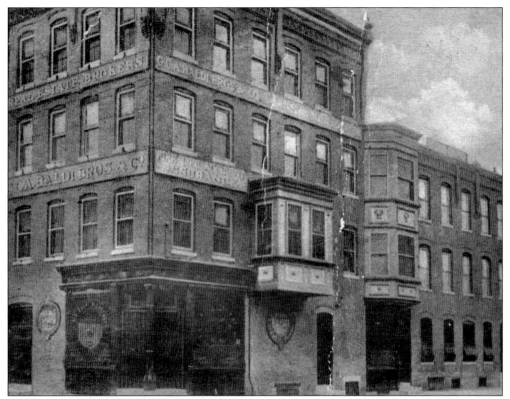

The First Italian Exchange Bank, owned by Charles C.A. Baldi Sr., was located on the corner of Christian Street, at 928 South Eighth Street. Baldi, a true Horatio Alger–like hero, emigrated from Italy to Philadelphia in 1877 at age 15, working as a lemon hawker. By 1914, Baldi's holdings included properties with a total value of $149,150 (equivalent to $3,368,656 in 2012).

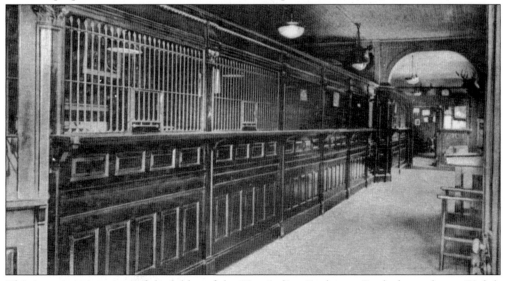

This is an interior view of the lobby of the First Italian Exchange Bank, located near Eighth and Christian Streets. Following in his father's footsteps, Charles Baldi Jr. also held a seat in the Pennsylvania House of Representatives between 1917 and 1936.

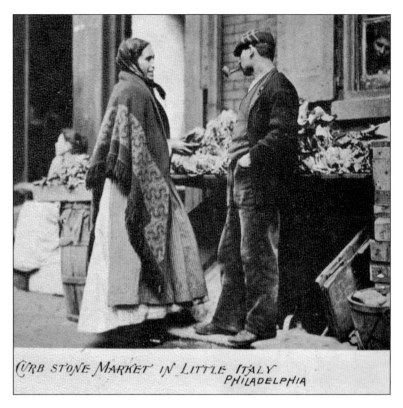

The Italian Market, also known as the South Ninth Street Curb Market, extends from Fitzwater Street to the north and Wharton Street to the south. In 2007, a Pennsylvania state historical marker was placed at the northeast corner of Ninth and Christian Streets. In this postcard from 1906, an Italian woman barters with a local vegetable stand vendor.

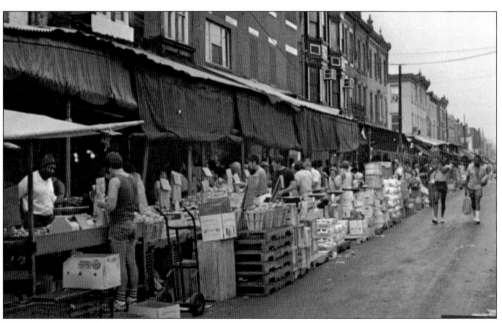

The name Italian Market is a moniker that evolved in the mid-1970s. This c. 1960 view shows vendors selling their wares at the open-air stalls of the South Ninth Street Curb Market.

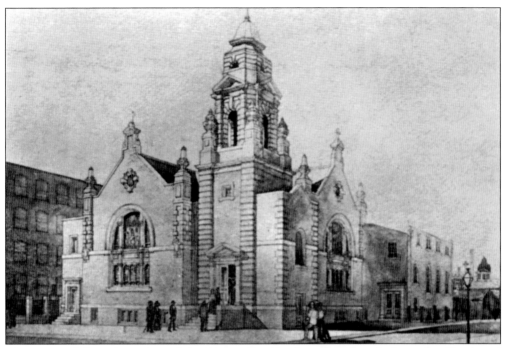

This postcard from 1913 showed the First Italian Presbyterian Church, located at Tenth and Kimball Streets. Established in 1903 by the Presbytery of Philadelphia, a successful campaign converted many of the area's large Roman Catholic Italian population to Presbyterianism. The church has since been renamed Christ's United Presbyterian Church and holds Indonesian- and Vietnamese-language services to accommodate the large Asian population now living in this South Philadelphia neighborhood.

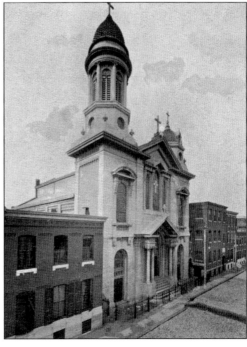

Founded in 1852 by Bishop John Neumann, St. Mary Magdalen de Pazzi Roman Catholic Church was the first Italian national parish in the United States. A postcard from 1905 shows the building located at 712 Montrose Street, a stone's throw from the Italian Market. According to legend, the famous tenor Mario Lanza sang the *Ave Maria* at this parish.

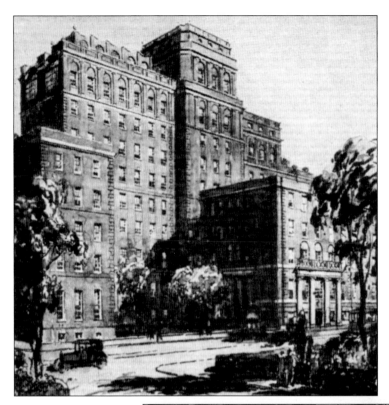

At the beginning of the 20th century, there was no hospital in South Philadelphia to treat its indigent Jewish population. The Mount Sinai Hospital was opened in 1905 under the leadership of Jacob Lit of Lit Brothers. Designed by architect Louis Magaziner, the building was located in the 1400 block of South Fifth Street. It finally closed in 1997 after many years of functioning as a busy community hospital.

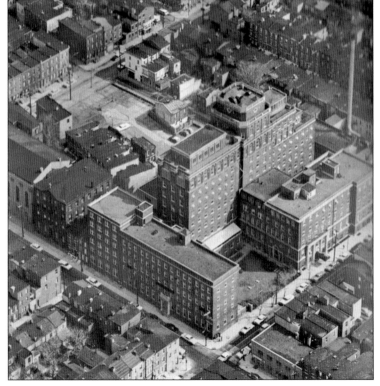

This is a c. 1960 bird's-eye view of the neighborhood surrounding the Albert Einstein Medical Center Southern Division (aka Mount Sinai Hospital). The multistory hospital building to the left of center, located on Fifth Street, near Reed Street, is surrounded by numerous row homes.

Nine

THE BROAD STREET RUN

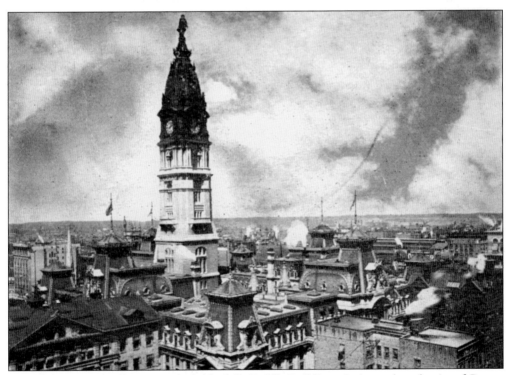

Philadelphia City Hall, previously dubbed the Public Buildings, is situated on the site of Center Square, the former pumping station that provided water to the city. City hall, including the statue of William Penn atop it, is a breathtaking 548 feet in height. It remained the tallest building in Philadelphia until 1984. This 1905 view, looking north, was taken from the Pennsylvania Building, located at Fifteenth and Chestnut Streets.

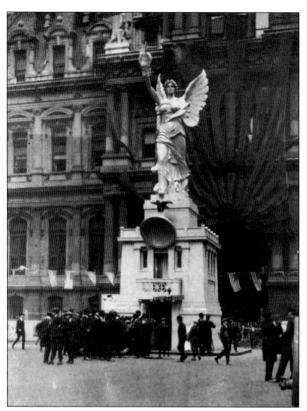

A statue of Victory is seen displayed within the city hall courtyard. The reverse side of the photograph states that the statue was unveiled on April 21, 1919, then razed in June of the same year.

In 1904, Broad Street, seen from Walnut Street, is a rather serene thoroughfare, with only a handful of horse-drawn carriages, wagons, and bicyclists in evidence.

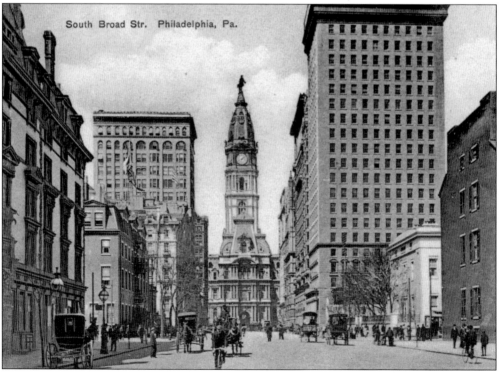

South Broad Str. Philadelphia, Pa.

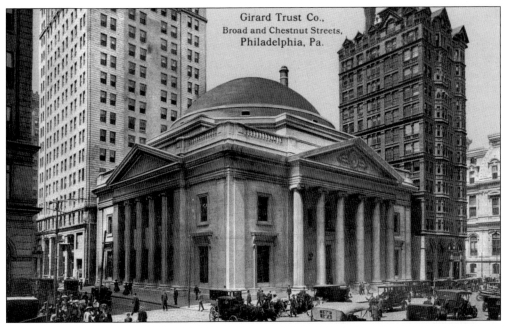

The Girard Trust Co. building, seen around 1910, is located on the northwest corner of Broad and Chestnut Streets. The West End Trust Building, demolished in 1928, was to its right. In 2000, the Girard Trust Building was converted into the lobby of the Ritz-Carlton Hotel.

The Dundas-Lippincott Mansion, otherwise known as the "Yellow Mansion," was situated on the northeast corner of Broad and Walnut Streets. Constructed around 1838, it was surrounded by manicured gardens and ornate iron fence work. In the late 1800s, it was considered to be the most valuable residence in Philadelphia. It was razed around 1905, the same year this postcard was postmarked.

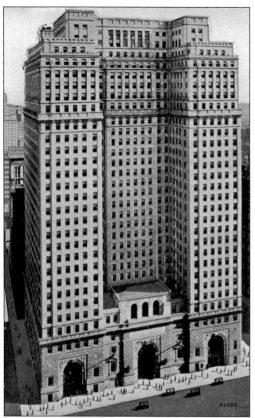

The 29-story Fidelity-Philadelphia Trust Building was erected between 1927 and 1928 on the northeast corner of Broad and Walnut Streets, the former site of the Yellow Mansion. The 405-foot-tall limestone-and-granite skyscraper is adorned with sculpture and large ornate bronze doors. After many mergers, the Fidelity-Philadelphia Trust Building was renamed the Wells Fargo Building.

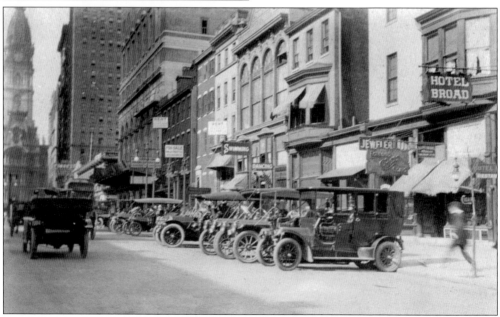

Diagonal curbside automobile parking was legal in the 1920s. This is a real-photo postcard showing the east side of Broad Street, between Sansom and Walnut Streets. The old Forrest Theatre marquee is in evidence at the end of the block.

The Manufacturers Club of Philadelphia was founded by a group of wealthy executives, most of whom were textile manufacturers. The club building, designed by the architectural firm Simon & Bassett, was erected in 1911 on the northwest corner of Broad and Walnut Streets. The building remains, although the club relocated in 1923 to suburban headquarters in Fort Washington, Pennsylvania.

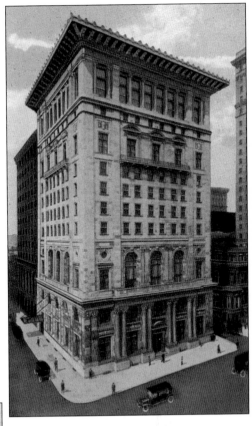

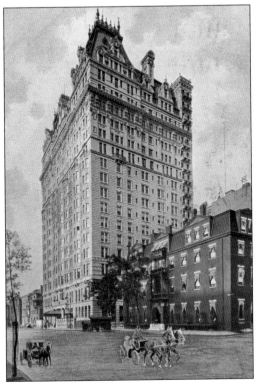

This postcard from 1908 is captioned "Bellevue-Stratford – New and Old Buildings." The Bellevue Hotel was a small, chic Victorian hotel on the northwest corner of Broad and Walnut Streets when it merged with the nearby Stratford Hotel. The Stratford was subsequently demolished, giving rise to the spectacular Bellevue-Stratford Hotel. Designed in the French Renaissance style by the prominent architectural firm G.W. & W.D. Hewitt, the 937-room hotel was opened in 1904.

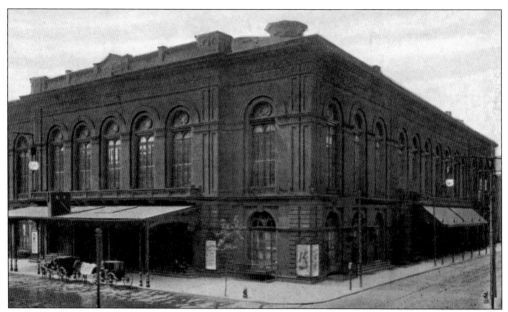

The Academy of Music, located on the southwest corner of Broad and Locust Streets, has been a mainstay of Philadelphia culture since its grand opening in 1857. Architects Napoleon Le Brun and Gustavus Runge created an auditorium with an "open-horseshoe" shape, allowing greater visibility for the audience seated in the balconies. The facade's overhanging awnings seen in this postcard from 1902 have long since been removed.

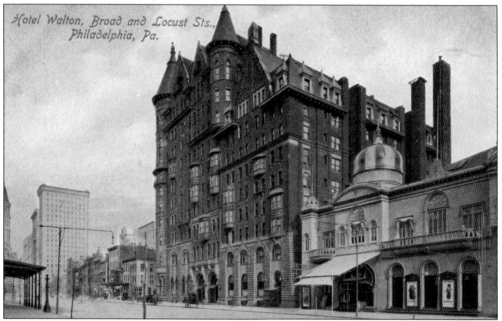

This postcard from 1903 reveals the looming castle-like appearance of the Hotel Walton on the southeast corner of Broad and Locust Streets, situated directly across the street from the Academy of Music. Completed between 1892 and 1895, it was later known as the John Bartram Hotel. The building was demolished in 1966. The domed Broad Street Theatre located next door to the Hotel Walton was demolished in 1937.

A corps of Philadelphia motor policemen participating in a Founder's Week parade, held on October 6, 1908, is seen passing in review in front of the judges' stand erected on the northwest corner of Broad and Spruce Streets. The Beth Eden Baptist Church is situated in the background.

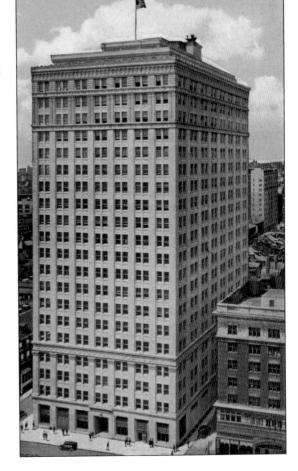

Viewed on this postcard from 1927, the Atlantic Building was completed in 1922 on the northwest corner of Broad and Spruce Streets, the site of the former Beth Eden Church. It was a 21-story office tower that has recently undergone renovations to become an apartment complex. The Shubert Theatre is directly to the right of the Atlantic Building.

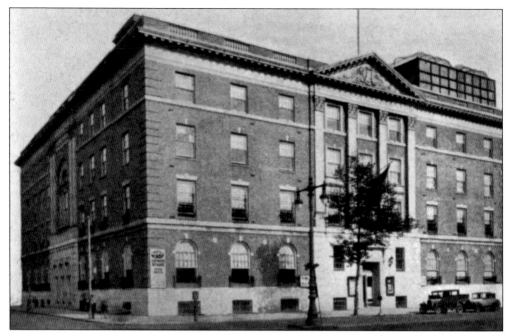

The doors of the Philadelphia Young Men's and Young Women's Hebrew Association, erected on the southeast corner of Broad and Pine Streets, opened in 1924. Seen here in 1924, it was designed by architect Frank E. Hahn and consultant Paul Cret and built at a cost of $1.25 million (over $16 million today). The building's four stories house a swimming pool, a 1,500-seat auditorium, and 13 classrooms.

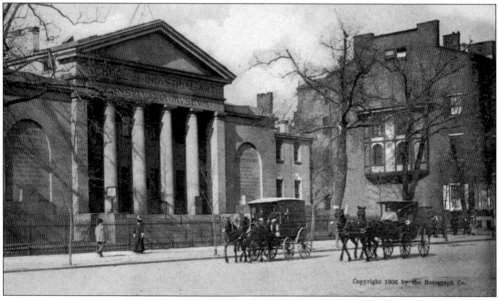

In 1824, the Pennsylvania School for the Deaf was designed in the Greek Revival style by well-known architect John Haviland. Subsequently, the enlarged and improved building came to be known as the School of Industrial Art of Pennsylvania. It is the oldest existing building on Broad Street, located on its west side, near Pine Street. It is currently called Dorrance Hamilton Hall of the University of the Arts.

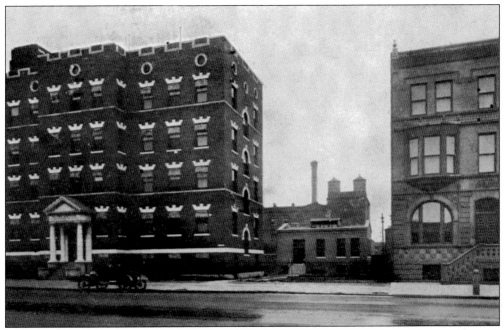

The Woman's Southern Homeopathic Hospital was located at 733–745 South Broad Street, near Fitzwater Street. It was founded in 1896 and built in 1909, with a bed capacity of 110 patients. This postcard from 1923 shows the hospital complex's Broad Street facade. The hospital was described as being "built for the patient of moderate means." The site is now a modern apartment complex.

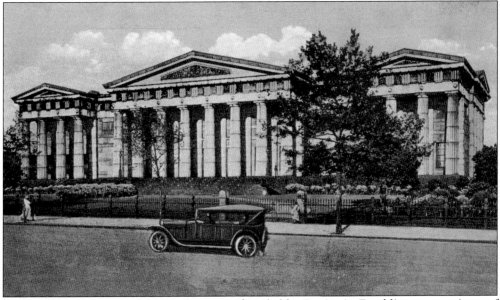

By the 19th century, the Library Company, founded by Benjamin Franklin as a repository of important manuscripts and printed material, had outgrown its shelves. As a result of a bequest from Dr. James Rush, the Ridgeway Library was erected between 1873 and 1878. Located at Broad and Christian Streets, the magnificent edifice was revitalized in the 20th century as the Philadelphia High School for the Creative and Performing Arts.

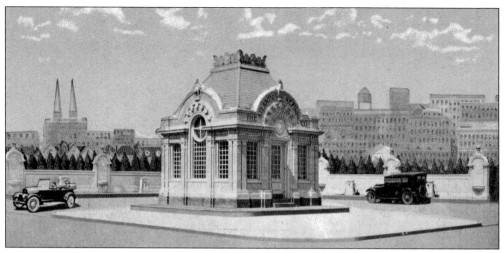

It is somewhat strange to see a gas station in the middle of a major thoroughfare. This Atlantic service station was located on an island near the middle of Broad Street at Carpenter Street. At that time, around 1910, gasoline prices were approximately 25¢ per gallon.

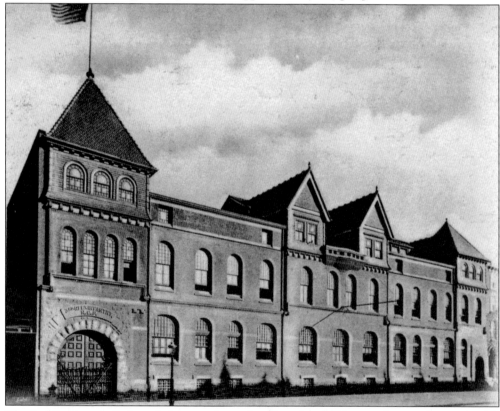

The 3rd Regiment (Infantry) Armory, located at Broad and Wharton Streets, is seen in this postcard from 1905. Built in 1886, the fortresslike structure housed the arms of the 3rd Regiment of the Pennsylvania National Guard. The unit was mustered into federal service in 1898 and again in 1916 for Mexican border service. The building was recently condemned and has been demolished.

The Combs Broad Street Conservatory of Music was located at 1329–1331 South Broad Street, between Reed and Wharton Streets. Founded in 1885 by Gilbert R. Combs, a well-known composer, pianist, and organist, it was the first college in Philadelphia to add music therapy to its curriculum. After relocating several times, the college finally closed in 1990.

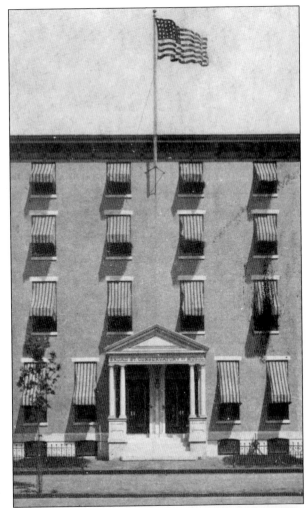

The view in this real-photo postcard of Dickinson Street, the cross street at the 1500 block of South Broad Street, looks northward toward Center City. The present exteriors of these homes remain remarkably unchanged from this 1905 photograph.

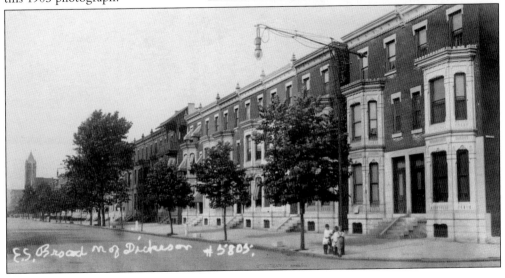

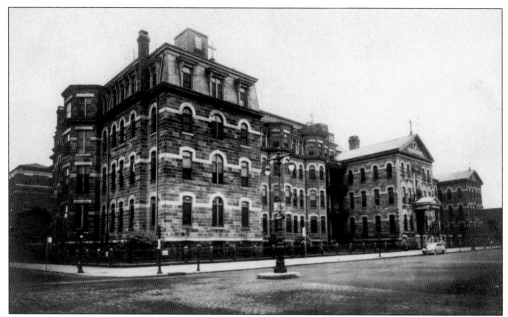

A 1933 real-photo postcard shows St. Agnes Hospital, located on the west side of Broad Street at McKean Street. Founded in 1879, it had a capacity of 335 medical, surgical, and obstetrical beds. Since the hospital's closure in 2004, a portion of its building space, now known as the Constitution Health Plaza, houses outpatient medical facilities and a hospice unit.

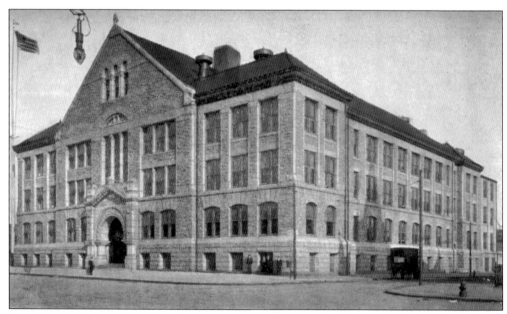

South Philadelphia High School, constructed in 1907 in the Norman Romanesque Revival style, was originally known as the Southern Manual Training High School for Boys. A later addition to the main building was designated as the School for Girls. The antiquated building was demolished in the 1960s, and a more modern structure was erected on the same site. This 1912 view was photographed at the corner of Broad and Jackson Streets.

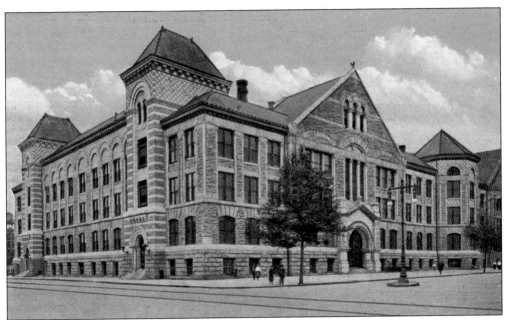

This is the Broad Street and Snyder Avenue side of the South Philadelphia High School. The school was originally opened as a three-year training facility for immigrant children. In perusing through the school's early yearbooks, it is quite evident that the students were mostly of Jewish and Italian descent.

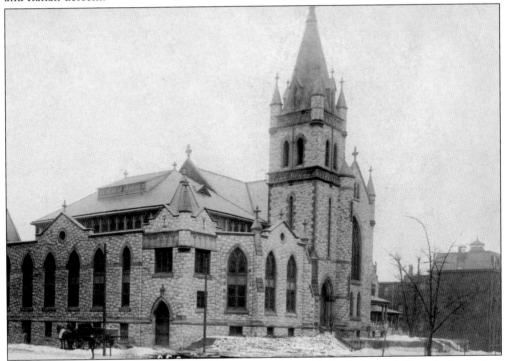

This real-photo postcard from 1906 shows St. Luke's Methodist Episcopal Church, located on the southeast corner of Broad and Jackson Streets, directly across from the South Philadelphia High School campus. A bank currently occupies this site.

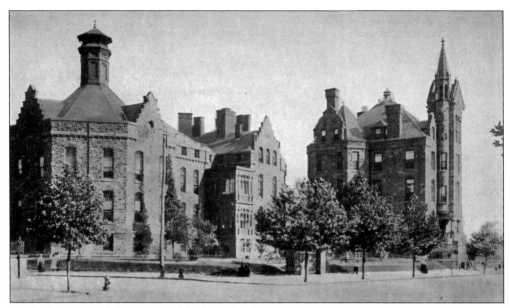

Methodist Hospital, located one block south of Saint Luke's Church at Broad and Wolf Streets, is seen in this postcard from 1914. Founded in 1896, it was a full-service general hospital with a bed capacity of 300. The hospital is now part of the Jefferson University system.

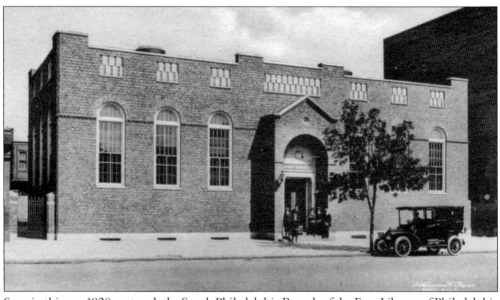

Seen in this pre-1920 postcard, the South Philadelphia Branch of the Free Library of Philadelphia was located at 2407–2417 South Broad Street, between Ritner and Porter Streets. Although the building remains standing today, the library was relocated farther down the block to 2437 South Broad Street in 1999 and dedicated as the Fumo Family Branch of the Free Library of Philadelphia.

Philadelphia selected the areas known as the Neck and the Ma'sh, the southernmost end of Broad Street, as the site for the 1926 Sesquicentennial International Exposition. There being but little time to spare, ground breaking for the 13.5-acre Sesquicentennial Stadium began in early 1925. The stadium's boundaries, seen in this aerial view of the construction site, encompassed Broad Street (seen diagonally on the left), Pattison Avenue (the horizontal road just above the stadium), and Eleventh Street. In order to accommodate the expected crowds, Broad Street had to be widened and lengthened from Oregon Avenue, past the exposition grounds, and down to the Navy Yard gate. It was the hope of all concerned that potential sesquicentennial sightseers would visit the naval base as well.

This is an aerial view of the completed $2 million (over $25.6 million today) Sesquicentennial Stadium, boasting a seating capacity of 100,000. After the exposition closed, it was renamed Philadelphia Municipal Stadium. In 1964, the name was again changed to John Fitzgerald Kennedy (JFK) Stadium. The structure was condemned in 1989 and demolished in 1992.

This interior photograph taken by William N. Jennings shows clear evidence that, as of January 29, 1926, much construction had yet to be accomplished to prepare the Agricultural Building for the opening day of the Sesquicentennial International Exposition, set for June 1, 1926.

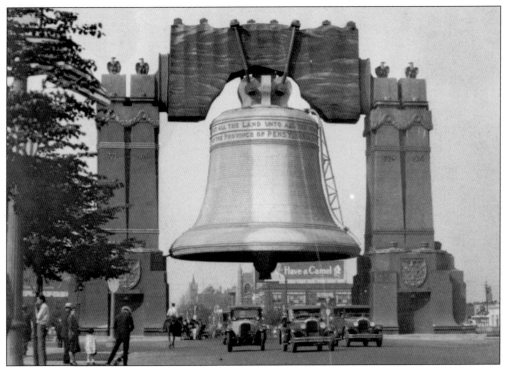

In order to enter the exposition grounds on Broad Street, vehicles had to pass beneath a colossal replica of the Liberty Bell that towered 80 feet above street level. At a construction cost of $100,000, it contained a profusion of 15-watt lamps, numbering approximately 26,000. Eight 200-watt projectors were situated within its clapper. When lit, the bell could be seen as far away as city hall.

John D. Cardinell, official publisher and photographer of the Sesquicentennial International Exposition, was responsible for its visual documentation. He took great artistic license in this scene by adding a number of dirigibles and single-engine planes to the airspace above the main entrance on Broad Street.

Barely visible at the far upper right, the Navy Yard gate was the terminus of South Broad Street. Seen in this photograph, Frank Vitor's 90-foot statue *The Spirit of Steel* commands the center lane of Broad Street. One of the exposition's many open-air jitney buses can be seen cruising along Broad Street's wide southbound lane, heading toward the Navy Yard.

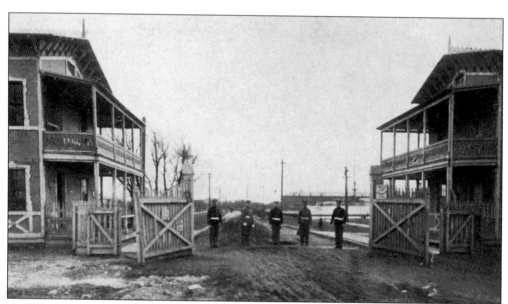

The Philadelphia Navy Yard was the United States' first naval shipyard. A view of the original Southwark yard can be seen on page 16. The shipyard was moved to League Island around 1870. The main gate on Broad Street, seen in 1910, was a rather flimsy, low-security affair. In 1926, prior to the Sesquicentennial International Exposition, it was replaced with a more ornamental structure of brick and wrought iron.

Veterans Stadium, commonly known as "the Vet," located at 3501 South Broad Street, opened in 1971. It was home to the Philadelphia Phillies and the Eagles. In 1971, seating capacity for baseball games was 56,371. The Vet's physical condition deteriorated, and Philadelphia was sorely in need of a new stadium. The Vet closed in 2003 and, in 2004, was imploded in a matter of 62 seconds.

Aquarama's $3 million Aquarium Theater of the Sea opened in 1962 on a large plot of unimproved land located at 3200 South Broad Street, bordering the Packer Park residential neighborhood, across the street from JFK Stadium. Aquarama was demolished in 1969. In the 1990s, a movie theater and fast-food hamburger chain built on that site were razed to make way for new residential and commercial ventures.

Discover Thousands of Local History Books
Featuring Millions of Vintage Images

Arcadia Publishing, the leading local history publisher in the United States, is committed to making history accessible and meaningful through publishing books that celebrate and preserve the heritage of America's people and places.

Find more books like this at
www.arcadiapublishing.com

Search for your hometown history, your old stomping grounds, and even your favorite sports team.

Consistent with our mission to preserve history on a local level, this book was printed in South Carolina on American-made paper and manufactured entirely in the United States. Products carrying the accredited Forest Stewardship Council (FSC) label are printed on 100 percent FSC-certified paper.

MADE IN THE USA